# IN & AROUND YORK DISTRICT
## THROUGH TIME

Paul Chrystal
& Simon Crossley

AMBERLEY PUBLISHING

# Acknowledgements

Special thanks to Ian Drake at York Architectural and York Archaeological Society (YAYAS) for permission to use images from the superb Evelyn Collection, and to Melvyn Browne for allowing us to use a number of his postcards throughout the book.

Paul Chrystal and Mark Sunderland are authors of the following titles in the *Through Time* series published in 2010: *Knaresborough*; *North York Moors*; *Tadcaster*; *Villages Around York*; *Richmond & Swaledale*; *Northallerton*.

Paul Chrystal and Simon Crossley are authors of the following titles in the series published or to be published in 2011: *Hartlepool*; *Vale of York*; *Harrogate*; *York Places of Education*; *Redcar, Marske & Saltburn*; *York Trade & Industry*; *Pocklington and Surrounding Villages*; *Barnard Castle & Teesdale*.

Other books by Paul Chrystal: *York Then & Now*, 2010; *A Children's History of Harrogate & Knaresborough*, 2011; *A-Z of Knaresborough History Revised Edn*, 2011; *Chocolate: The British Chocolate Industry*, 2011; *York and Its Confectionery Industry*, 2011; *Confectionery in Yorkshire – An Illustrated History*, 2011; *Cadbury & Fry – An Illustrated History*, 2011; *The Rowntree Family and York*, 2012; *A-Z of York History*, 2012; *The Lifeboats of the North East*, 2012.

All the modern photography is by Paul Chrystal. To see more of Simon Crossley's work please go to www.iconsoncanvas.com; to see Mark Sunderland's work visit www.marksunderland.com. For more information on YAYAS and the Evelyn Collection go to www.yayas.free-online.co.uk

*To the memory of Dr William Arthur Evelyn (1860–1935)*

First published 2011

Amberley Publishing
The Hill, Stroud,
Gloucestershire, GL5 4EP

www.amberley-books.com

Copyright © Paul Chrystal & Simon Crossley, 2011

The right of Paul Chrystal & Simon Crossley to be identified as the Authors of this work has been asserted in accordance with the Copyrights, Designs and Patents Act 1988.

ISBN 978 1 4456 0215 8

British Library Cataloguing in Publication Data.
A catalogue record for this book is available from the British Library.

Typeset in 9.5pt on 12pt Celeste.
Typesetting by Amberley Publishing.
Printed in the UK.

# Introduction

On 19 January 1891, Dr William Arthur Evelyn stepped off the train from London at York railway station. The view which greeted him would have been much the same as the one which now greets thousands of visitors every day – the imposing city walls extending along their embankment. We can assume that the effect of this first sight on Dr Evelyn was responsible in large part for him becoming, as Hugh Murray says in his book *Doctor Evelyn's York,* 'a pioneer of conservation of the City between 1891 and 1935'. Indeed, had Dr Evelyn not made that propitious journey York would probably be a very different, less impressive place today.

I have been fortunate to be able to include a number of images from the Evelyn slide collection, which he bequeathed to York Architectural and York Archaeological Society (YAYAS) . They make up Chapter One of the book and set the tone perfectly, providing as they do a unique and highly atmospheric picture of one of England's finest cities as it was in the first part of the twentieth century. Dr Evelyn arrived in York as a physician. By the time he died here in 1935, he and his colleagues at YAYAS had helped to preserve much of what makes the city what it is today, as evidenced by many of the modern photographs in this book.

The second half of the book is a tour around many of the delightful villages which surround the city – again the old is juxtaposed with the new, to give a picture of how much, or how little, has changed. The book takes a fairly wide orbit, extending to Bulmer to the north, Claxton to the east, Escrick to the south and the Poppletons to the west. Obviously, our scope is determined by the images available at the time of writing but, fortunately, we have been able to offer a fairly comprehensive view of the villages which surround York.

Paul Chrystal, York
September 2011

Villages included in *In & Around York District Through Time*:

Bishopthorpe; Bulmer; Claxton; Escrick; Flaxton; Heslington; Hopgrove; Nether Poppleton; Osbaldwick; Sand Hutton; Sheriff Hutton; Stillington; Shipton by Beningborough; Skelton; Stockton-on-the-Forest; Sutton-on the-Forest; Upper Poppleton.

Haxby, Huntington, New Earswick, Strensall and Wigginton feature in *Villages Around York Through Time* published in 2010.

Alne, Easingwold, Nun Monkton, Tollerton, Kirk Hammerton and Green Hammerton will feature in *Vale of York Through Time* to be published in 2011. Market Weighton, Pocklington, Barmby Moor and Stamford Bridge are in *Pocklington & Surrounding Villages Through Time* to be published in 2011.

One of the pictures below shows the Minster lit up during the Illuminating York Festival in October 2010. The festival is in its sixth year and uses lighting and projection technology, created by Ross Ashton and Karen Monid, to showcase York's architecture. The other is of the famous 'Purpleman' outside the Minster in August 2011.

Page 5 shows the gasworks in Monkgate from the Evelyn Collection. The modern picture shows the day that *Antiques Roadshow* came to York's Museum Gardens, in July 2011. The unique gold and sapphire ring, recently bought by the museum for £35,000, is being scrutinised by Geoffrey Munn.

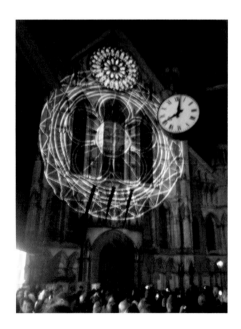
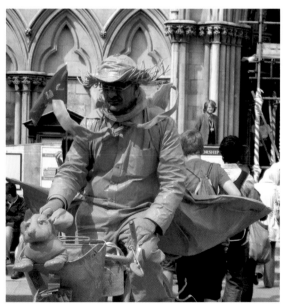

CHAPTER 1

# York I: From the Evelyn Collection

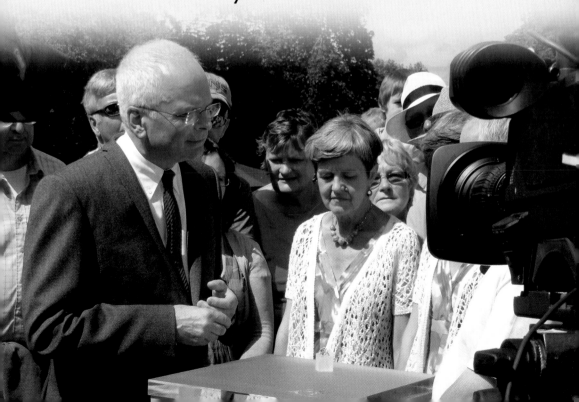

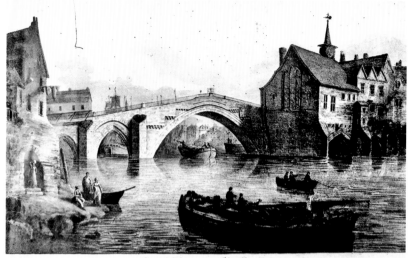

*Ouse Bridge and St William's Chapel.*
YORK.

### Old Ouse Bridge

The very first bridge to span the Ouse was built by the Romans at the end of what is now Stonegate. The Vikings replaced this with their own wooden bridge, which collapsed in 1154 under the weight of the spectators congregating to see the return of St William of York from exile. It was replaced by a stone bridge, part of which was swept away by floods in 1564–5. It was occupied by about fifty shops, a town hall and a hospital. England's first public toilets are also reputed to have opened here (issuing into the river, no doubt). It in turn was replaced by the bridge shown. On the right is the twelfth-century St William's Chapel, from a drawing by Thomas Taylor in 1806. The new picture shows modern riverside activity on the Ouse at King's Staith.

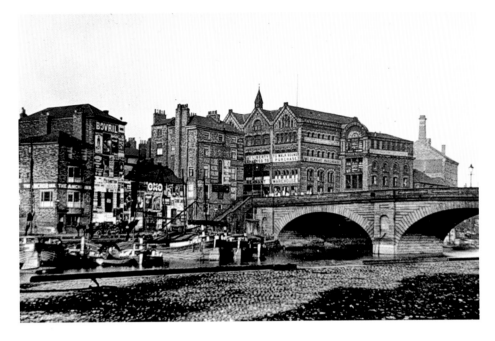

### New Ouse Bridge

After the flood damage, a replacement bridge was built 1565, the new central arch of which spanned 81 feet. Defoe, in his *Tour Through the Whole Island of Great Britain* described it thus: 'near 70 foot in diameter; it is, without exception, the greatest in England, some say it's as large as the Rialto at Venice, though I think not.' It was dismantled between 1810 and 1818 and replaced by the New Ouse Bridge, completed in 1821, pictured here. This shot, looking towards Boyes, was taken just before the fire in 1910. The modern picture shows more riverside café society, what was the Boyes building, and the Park Hotel.

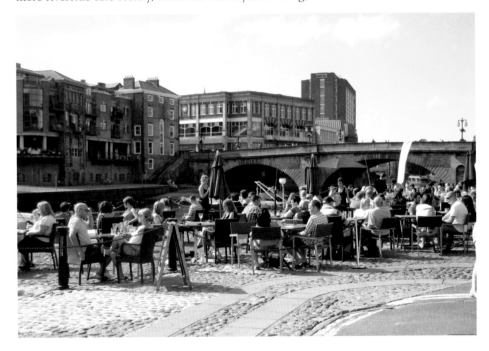

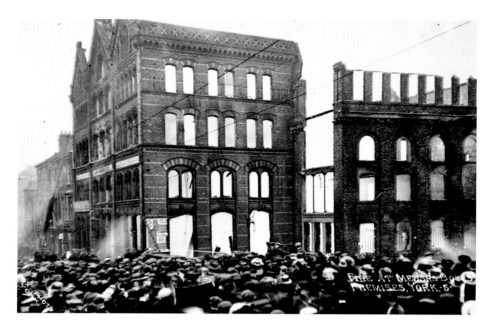

## The Fire at Boyes

The devastating fire at the Boyes building on Ouse Bridge, 8 November 1910. It started on the second of six floors, when paper decorations in the toy department were set alight by a nearby gas lamp. Despite the efforts of the fire brigade, assisted by the Rowntree Fire Brigade, the building was a smouldering shell six hours later. Boyes' Scarborough store also burnt down in 1914. Today's photograph shows fire-raising of a less destructive kind on the approach to Ouse Bridge.

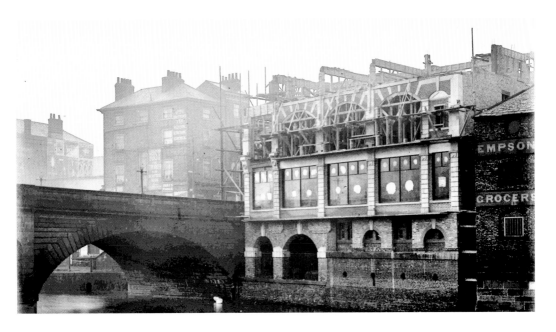

## Burnt-Out Boyes on Ouse Bridge

The old shop had been trading since 1906. Boyes' new shop was completed in July 1912 and closed down in 1983, to reopen in Goodramgate in 1987. Tolls were charged on Ouse Bridge for the crossing to defray the building costs, although these were relaxed in 1829 for traffic carrying materials to repair the Minster after the fire. River traffic on the Ouse is shown in the new picture, taken from Lendal Bridge and looking towards Ouse Bridge.

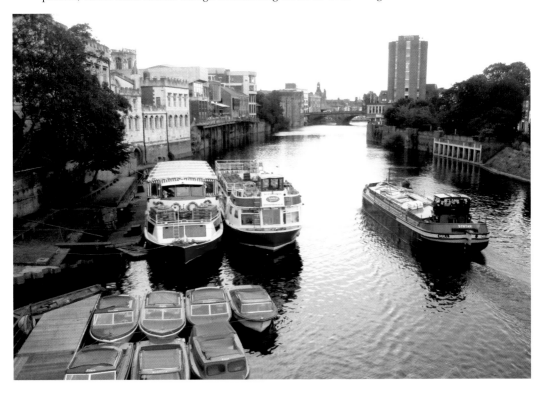

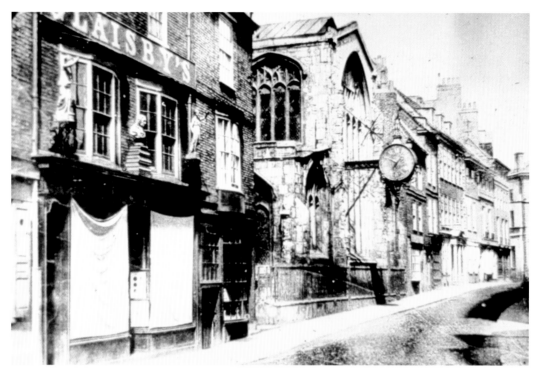

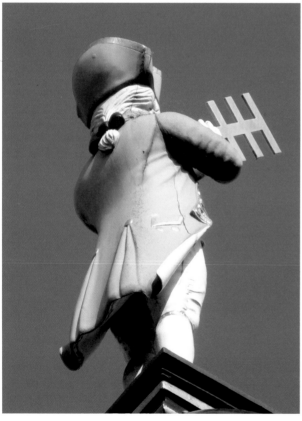

**Coney Street Before Baedecker**
This shows John Glaisby's bookshop and library, which until 1848 had been the premises of William Hargrove's *York Herald*. It was next to the George Hotel and known then as Kidd's Coffee House. Hargrove bought it from Caesar Peacock, owner of the *York Courant*, in 1815; the *Courant* had been moved there from the Bagnio by Ann Ward (see page 40). The magnificent statues and the bust and books have sadly gone. However, the publishing heritage of the building was extended when it became the offices of the then *York Evening Press* and the *Yorkshire Gazette and Herald*. The 'Little Admiral' on the 1778 clock was bombed to the ground during the 1942 Baedecker Raid. Luckily it was found by Eric Milner White, Dean of York, and kept until the restoration of the clock in 1966. The old photograph is by George Fowler Jones, taken in 1853.

# AN EXECUTION BEHIND YORK CASTLE IN THE OLDEN TIME.

## Castle Executions

Executions were held on the Knavesmire up until 1802, when the gallows were transferred to the castle (The New Drop) and then, in 1868, to a drop within the prison nearby. Dick Turpin is, of course, the most notorious Knavesmire, or Tyburn, victim – one of many who died there. For example, Duke 'Butcher' Cumberland, on his victorious return from Culloden, left a number of prisoners here to show his gratitude for the city's hospitality. The sheriff's chaplain read out the message: 'And the Lord said unto Moses "Take all the heads of the people and hang them up before the sun"'. Twenty-three were duly left to hang for ten minutes, before being stripped and quartered and their heads stuck on Micklegate Bar. Cumberland Street was named after the Duke. The engraving is by Thomas Gent – the cupola on the 1705 Debtors' Prison is visible in the background. Activity behind the castle nowadays is altogether less gruesome, as the new photograph clearly shows.

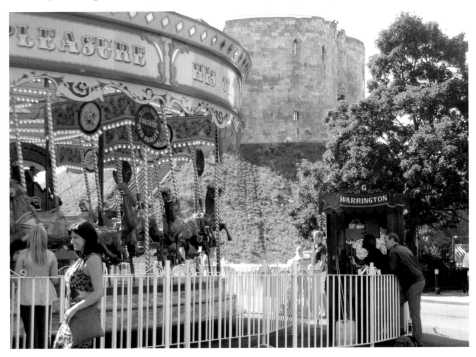

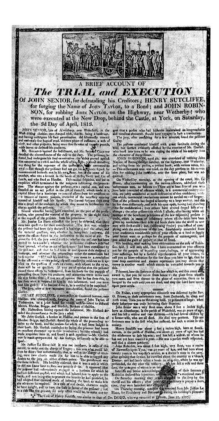

The Trial and Execution of Henry Senior and Others

The New Drop, near the castle, was where the roundabout at St George's car park is today. Roughly opposite, in the museum wall, is a small doorway through which the condemned, including Henry Senior in 1813, were led to the gallows. Senior, aged forty, was hanged, along with Henry Sutcliffe and John Robinson, on Saturday 3 April 1813. Senior's crime was defrauding his creditors – the first man in Yorkshire to swing for this felony. Sutcliffe, twenty-nine, was executed for forgery; Robinson, also forty and a former ship's doctor's mate, then a quack, was hanged for robbing John Naylor, a butcher from Boroughbridge. One of the cells, now part of the Castle Museum, is pictured in the new photograph.

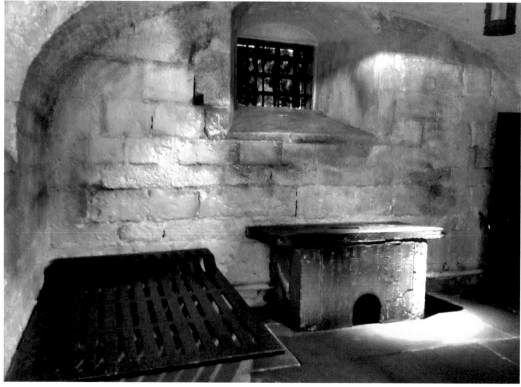

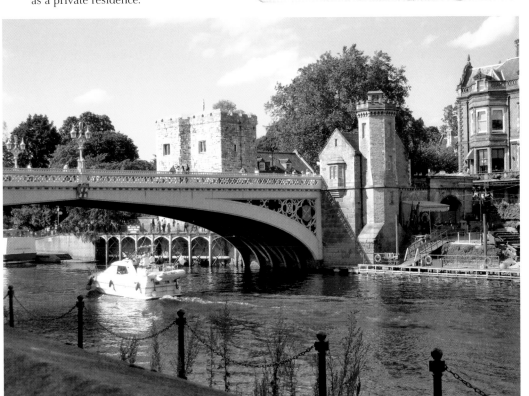

**Lendal Baths**

The illustration shows the Tower and adjoining house before Lendal Bridge was built. Lendal Tower was built around 1300 as part of York's defences. It housed an iron chain that could be extended to Barker Tower opposite, to keep out hostile boats and to help extract tolls (see page 41). In 1677 the tower was leased for 500 years to the York Waterworks Company and provided York's water supply until 1836, when the dedicated red-brick engine house was built. The tower was put on the market for £650,000 in 2001 and sold as a private residence.

13

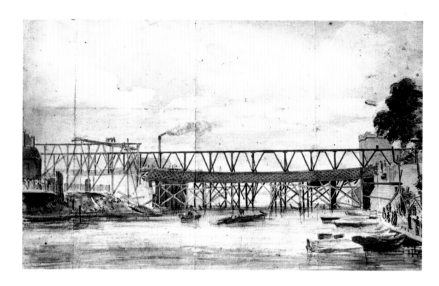

### Old Lendal Bridge

The arrival of the railways put considerable pressure on the ferry service that operated between Lendal to Barker Towers. After considerable argument between the Corporation of York and the railway companies, the York Improvement Act was passed in 1860. The Act allowed the construction of the first Lendal Bridge, designed by the aptly named William Dredge, in 1863. Jon Leeman was the last ferryman – he received £15 and a horse and cart in redundancy compensation. Unfortunately, this bridge collapsed during construction killing five men. It was replaced by the present bridge, designed by Thomas Page, who was responsible also for Skeldergate Bridge and Westminster Bridge. The newer photograph shows the bridge with its resplendent V&A insignia (honouring Queen Victoria and Prince Albert) and the crossed keys of St Peter symbolising the Minster, with the Guildhall in the background.

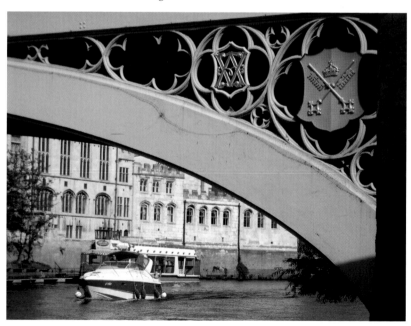

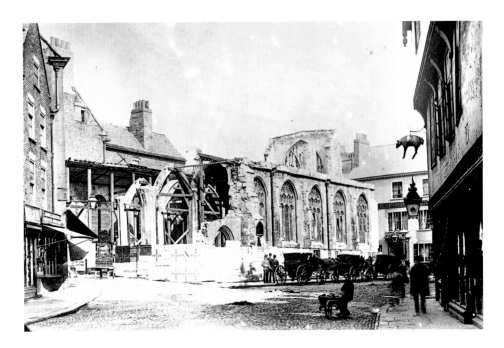

## St Crux Being Demolished

One of the most heinous acts of Victorian civic vandalism to be visited on a city was the dynamiting of the cupola-topped St Crux in Pavement in 1887. The unhappy photograph captures the tragedy of the event, thrown into relief by the sign of the Golden Fleece opposite, evoking images of lambs to the slaughter – a beautiful medieval church was hung out to dry, and the city was fleeced of one of its marvels.

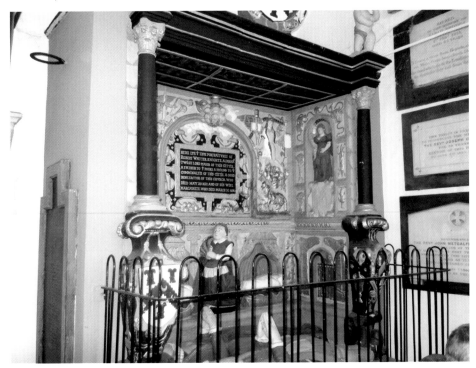

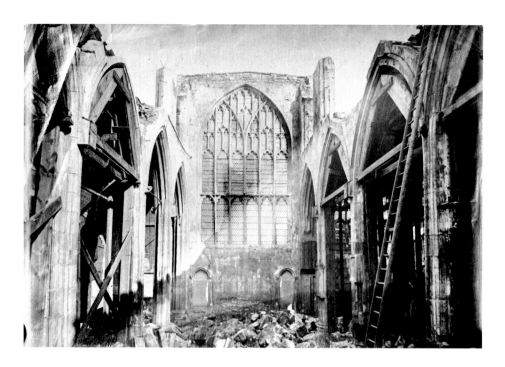

### St Crux Demolished

More happily, some of the church's treasures can still be seen in the Parish Hall, which was built from the rubble. Not least of which is the beautiful 1610 monument to Sir Robert and Lady Margaret Watter, shown here and on the previous page. Watter was Lord Mayor of York in 1591 and 1603. He bestowed his gold chain of office on the city, and it has been worn by every York Mayor since. See also page 53.

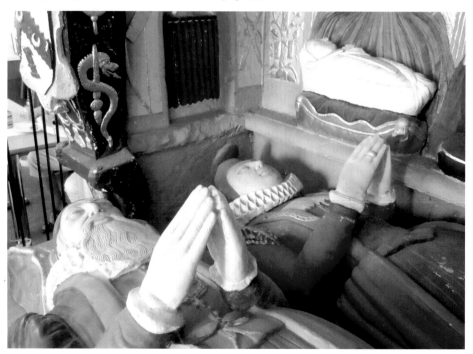

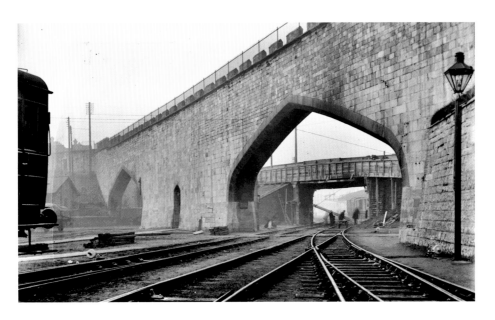

### The Old York Station

Built in 1841 and replaced in 1877 by the present impressive York railway station, the old station was demolished in 1966. This was York's second station built under the aegis of George Hudson – the first was a temporary wooden building near Queen Street Bridge, opened in 1839 by the York & North Midland Railway. However, the Railway King's Tanner Row station was far from ideal: it was a terminus and through trains from London to Newcastle had to reverse out in order to continue their journey. Accordingly, a new station was built outside the walls – the present 1877 station. It had thirteen platforms and was at that time the largest station in the world. The modern image shows the Cedar Court Hotel & Spa, formerly the headquarters of LNER.

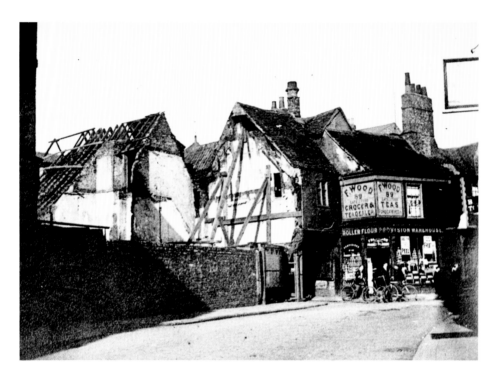

### Knocking Down Goodramgate

Knocking down buildings to give access for a new road up to the Minster – Deangate – in 1903. Casualties were John Wharton's Cheap Shop at No. 87 and Webster's the cobblers at No. 86. Women's boots here cost 1s 6d (7½p) to sole and heel; men's 2s 6d (12½p). Wood's grocer's and tea dealer's – they also sold foreign wines – survives today as the National Trust shop.

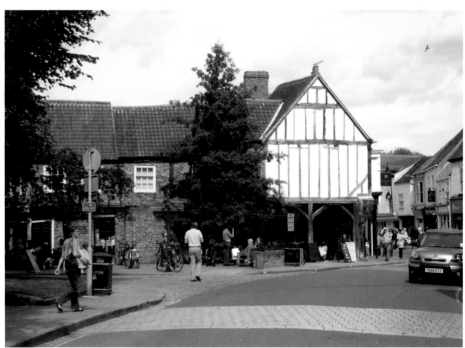

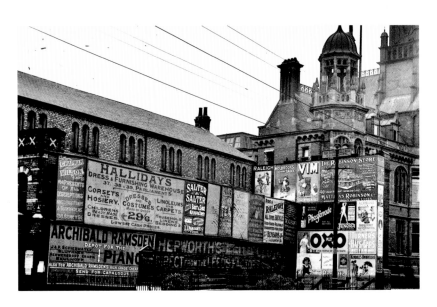

Clifford Street

An example of the off-the-wall advertising which afflicted York and other towns and cities in the nineteenth and early-twentieth centuries, blighting many a fine building. Ghost advertisements survive today in the guise of the Bile Beans advert in Lord Mayor's Walk and the Stubb's advert on Foss Bridge – these of course are painted advertisements unlike this paper blizzard in Clifford Street. Dr Evelyn was no fan, but this was clearly one of the few means of marketing your business, or event, in those days. Despite the efforts of the 1893 National Society for Checking the Abuses of Public Advertising, nothing much changed. The York Corporation Act of 1902, which banned sandwich boards that required two people to carry them, vehicles used exclusively for advertisements, and hoardings over twelve feet high, had no effect. The main building shown here is the 1856 Trinity Chapel, which was converted into the Fire Station in the 1930s.

### The River Foss

A delightful early photograph of the River Foss. Pictured today flowing under Haxby Road, it comes from its source in the Howardian Hills through Sheriff Hutton and Strensall, skirting Haxby and Joseph Rowntree's model village at New Earswick, before it enters the city to join the Ouse.

## The Old Clock on the Minster

From 1750 until 1871 the south entrance to the Minster was surmounted by this splendid clock. More famous today is the Astronomical Clock installed in 1955 as a memorial to the Yorkshire-based Allied aircrew who flew from bases in Yorkshire and the North-East and who died during the Second World War. One face shows the precise position of the sun in relation to the Minster at any given time, while the other gives the position of the northern stars by which aircrew would have navigated. The 1749 Striking Clock by Henry Hindley in the North Transept, shown here, features two carved oak figures or 'Quarter Jacks' who strike the hours and quarters with their rods. The old picture also shows the Minster Police on duty (see page 45).

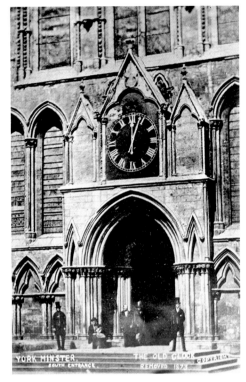

YORK MINSTER, SOUTH ENTRANCE. THE OLD CLOCK COPYRIGHT. REMOVED 1871

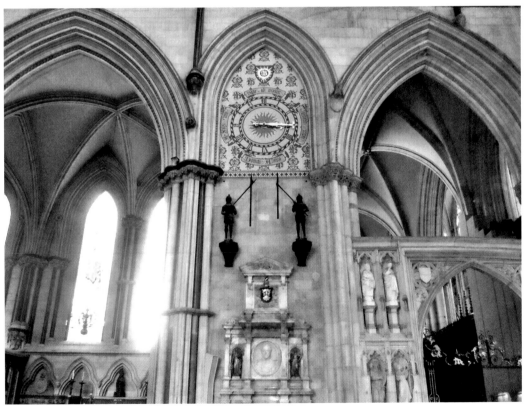

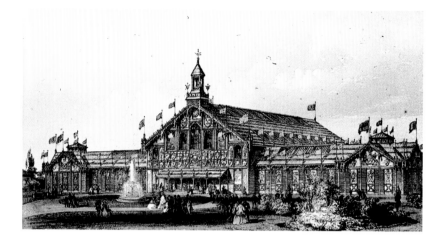

### The Great Exhibition Hall and Cock Fighting

York Art Gallery was built in 1879 for the second Yorkshire Fine Art and Industrial Exhibition, which drew more than half a million visitors and made a profit of £12,000. The Great Exhibition Hall served as a a venue for boxing and cockfighting as well as exhibitions until 1909. It was bombed during the Second World War and demolished in 1942. The modern picture shows one of York's Bars under seige. Displayed at the Hungate dig, it is one of twenty-four paintings produced by Mary Pasari, Cheryl Colley and Lisa Nicholson in a partnership between York Archaeological Trust, the Arts and Culture Service at the City of York Council, Hungate (York) Regeneration Ltd. They were produced by five community groups, involving over fifty people. Each group included the three Yorkshire artists, adults with mental health issues and learning difficulties, older people in sheltered housing, and homeless people in the city – all working for three months to create the paintings, which are based around history, people, views from the walls, nature and stonework.

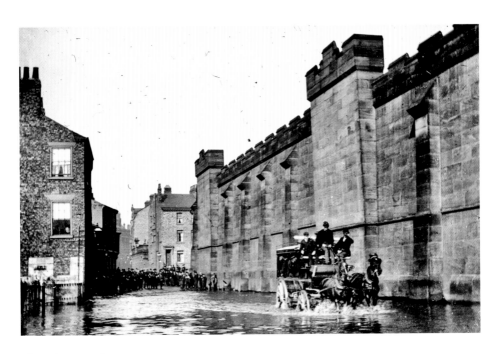

### The Prison Walls

These enclosed the Debtor's Prison and the Female Prison – both now occupied by the Castle Museum which has a section devoted, appropriately, to prison life. The cells in which prisoners like Dick Turpin spent their last days before execution can be visited (with impunity). Turpin was hanged for horse stealing in 1739. The older photograph shows floods in Tower Street in 1892. The walls were demolished in 1935.

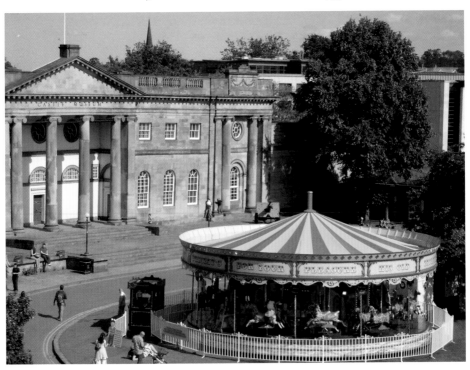

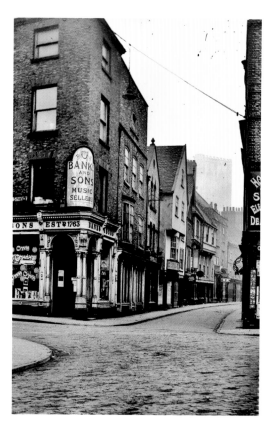

## Bank's for Music

This photograph is from 1921. Situated on the corner of Blake Street and Stonegate, Bank's can point to a long tradition of supplying musical instruments, sheet music and music in one form or another down the years. Their current shop has been in Lendal since the 1980s and is shown here with an impressive window display.

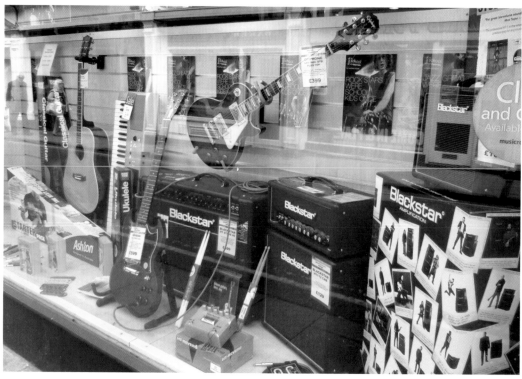

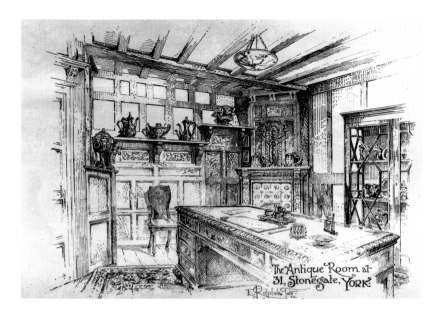

The Antique Room at 31, Stonegate, YORK

### Henry Hardcastle

A jewellers in the early-twentieth century, the shop at 31 Stonegate carries on the same trade today, under the guise of Walker & Preston's. The new photograph shows a number of the treasures for which Stonegate is famous: the scarlet Printer's Devil (signifying the importance of printing and publishing here) on the corner of Coffee Yard (a tribute to the coffee houses which were clustered around); the 'sign of the Bible' in the doorway of the Haunted House – formerly Hardcastle's Bookshop; the famous sign for Ye Olde Starre Inne, and the remains of the highly ornate façade on what is now the Haunted House. The drawing is by Edwin Ridsdale Tate who flourished between 1862 and 1922.

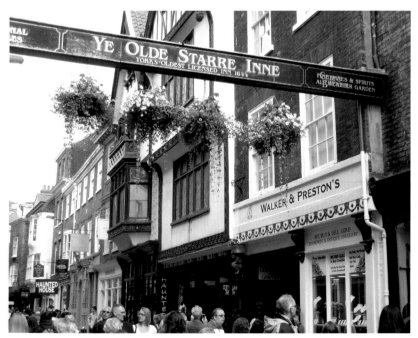

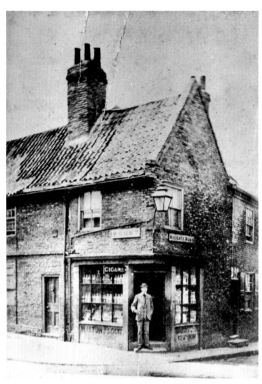

### The Mount

A pre-1889 shot of the Mount-Holgate Road corner; this shop was replaced that year with a larger shop that John Bentley, the owner, ran until 1914. In the modern photograph, you can just make out the sign for the Co-op above the doorway. The inset shows the 1832 Mount public house (called the Saddle until John Smith bought it in 1892) round the corner, with its mounted cavalryman sign.

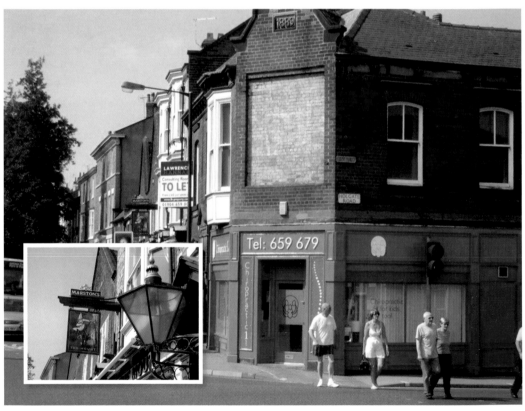

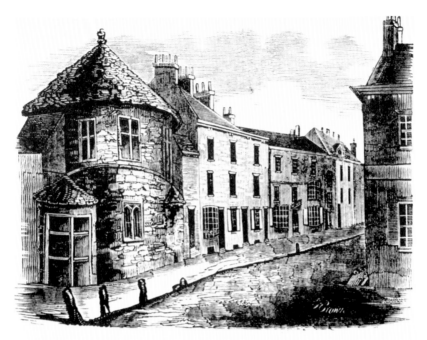

*Abbey Tower corner of Marygate & Bootham.*

### St Mary's Tower

Built about 1325, the tower was used to store monastery records after the Dissolution in 1539. During the Civil War in 1644, however, the Earl of Manchester blew it up with a mine. The documents which survived were salvaged by Richard Dodsworth and are now in the Minster Library. The tower has been rebuilt (see also page 42). A contemporary account tells us that 'Samuel Breary ... Lieutenant Colonel of a Company of 250 stout Volunteer Citizens, being shot with a poysoned Bullet into one of his Arms, four days after dyed.' The new photograph shows the tower today, from Marygate looking towards Bootham.

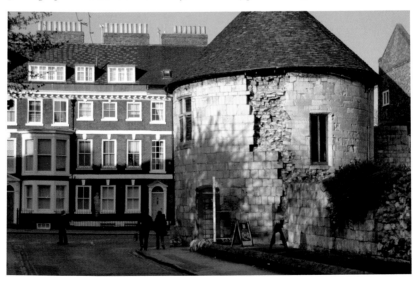

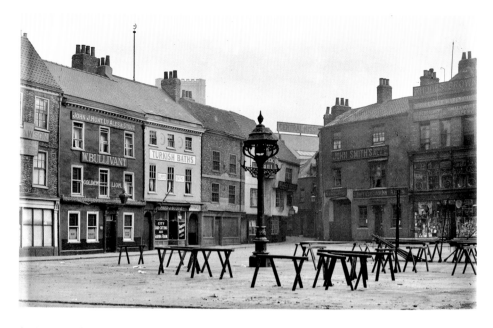

### St Sampson's Square and the Turkish Baths

The Turkish Baths here later became Shepherd's City Baths and continued to offer Turkish and slipper baths. They were flanked by pubs: the Golden Lion on the left (run by M. Bullivant and serving John J. Hunt's ales); the Black Bull Hotel, also on the left; and the Three Cranes and the Exchange across the square, the latter an H. Bentley & Co. house. Rhodes Brown, haberdasher's, was next to the Three Cranes. The modern picture shows some high-flyers in the square in August 2011.

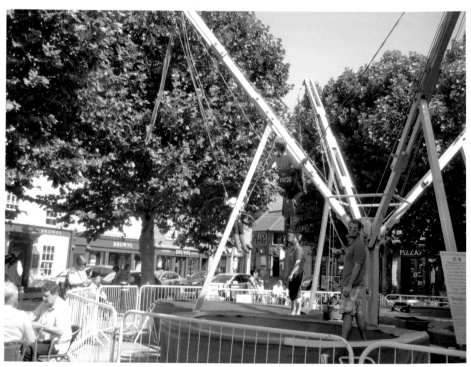

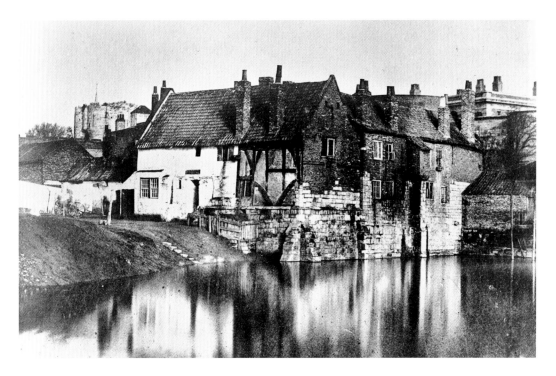

### Windmill Inn, St George's Field

The Windmill Inn in St George's Field on the Foss with Clifford's Tower in the background. Records of its existence date from 1782. The inn was demolished in 1856 to improve river access to the Glassworks on the opposite bank. The works themselves were later demolished to be replaced by the Novotel.

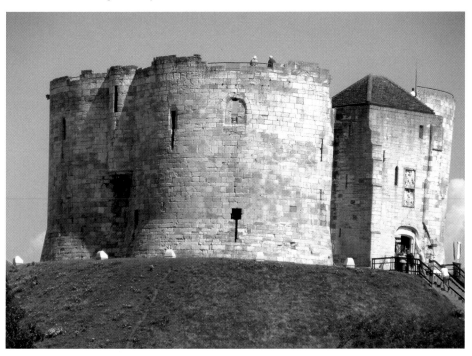

"WALKS THRO' OLD YORK"

GHMilburn
1920.

Dr Evelyn and the Fingerprints of the Vandals in York

We have Dr W. A. Evelyn (1860–1935) to thank for the preceding photographs and images of York. In 1905 he organised an exhibition in York Art Gallery – York Views and Worthies – which included some of these and other images of York. He started his famous series of lectures in 1909 and in 1934 he donated his huge collection of pictures to the city, to be held in the Gallery. A fervent defender of the city's heritage and member of York Architectural and York Archaeological Society (YAYAS), Dr Evelyn campaigned tirelessly against the destruction or ruination of many of York's finest sights. The collection is accessible through YAYAS, www.yayas.free-online.co.uk.

Corporation Art Gallery, York.

THE ETTY EXHIBITION,

February 20th to April 8th, 1911.

ILLUSTRATED

Lantern Lecture,

By DR. W. A. EVELYN,

"Finger Prints of the Vandals in York."

Chairman: MR. W. F. H. THOMSON.

Wednesday, March 1st, at 8 p.m.

CONCERT

(Organised by Miss GROVES),

Saturday, March 4th, 1911, at 8 p.m.

ADMISSION THREEPENCE.

York. Herald Co., York.

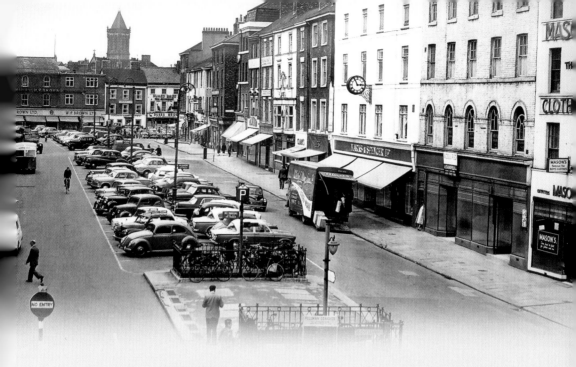

CHAPTER 2

# York II

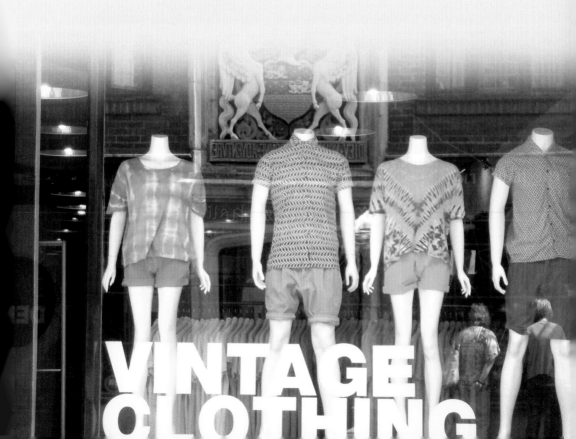

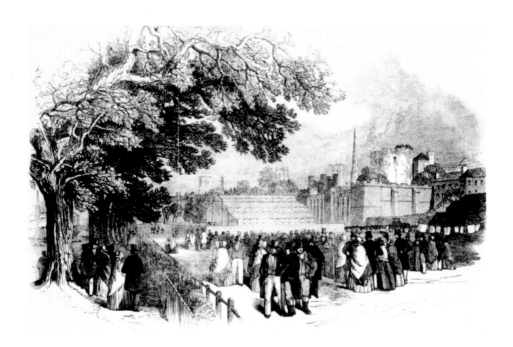

### Royal Agricultural Society

This shows the 1848 joint Great Yorkshire and Royal Shows, which took place over one week. The viewpoint of the engraving is from the New Walk, with the dinner pavilion in the centre, Clifford's Tower and the now-demolished prison walls to the right. The Society was inaugurated in 1837 by a group of agriculturalists at a meeting in the Black Swan Hotel, Coney Street. They decided that their objectives would be to establish 'an annual meeting for the exhibition of farming stock, implements, etc. and for the general promotion of agriculture'. The new picture shows the Millennium Bridge at the end of the New Walk.

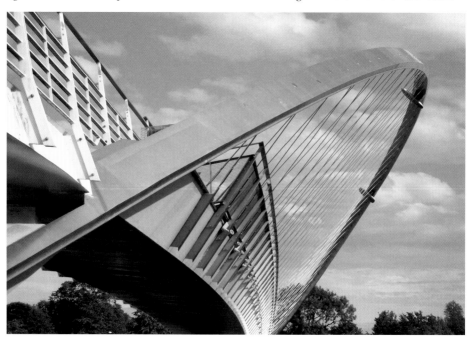

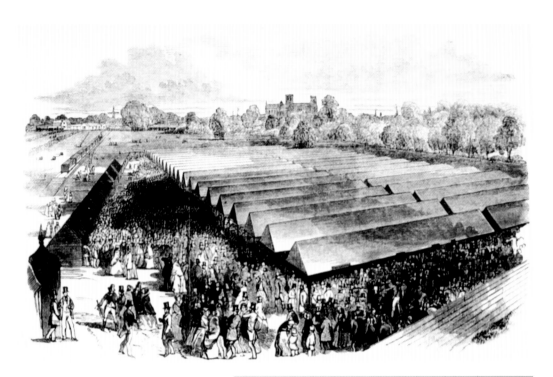

## The Cattle and Implement Sheds

The first meeting was held in York in 1838 at the Barrack Yard of the 5th Dragoon Guards. So popular was it that a near-riot began at the Members' gate where soldiers and police 'were obliged to use their sticks, the blows of which were returned'. The massive sheds pictured here were built on Bootham Stray for the 1848 event. The specially extended branch railway can be seen top left with the Minster in the centre of the engraving. Today's photograph shows the Minster from Bootham.

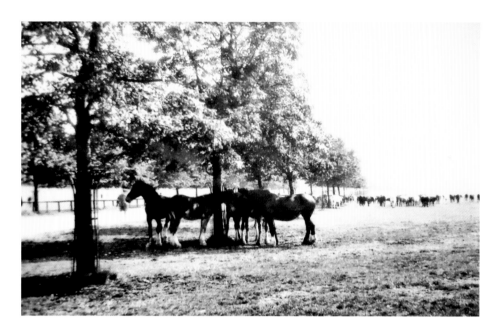

## The Knavesmire and Grazing Horses

Grazing horses and cattle were a common sight on the Knavesmire from the early-nineteenth century through to the 1960s, originally because local householders held grazing rights here. Grazing was the traditional way of managing the pasture. Indeed, it is much cheaper than mechanised grass-cutting and, with that in mind, grazing has been reintroduced on a number of the city's strays with help from the Natural England Environmental Stewardship Scheme, which has awarded York £500,000 over the next ten years to help with the work. The 2011 picture is of racegoers heading for the city across the Knavesmire after the July meeting.

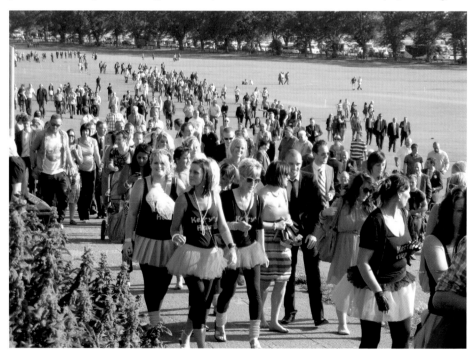

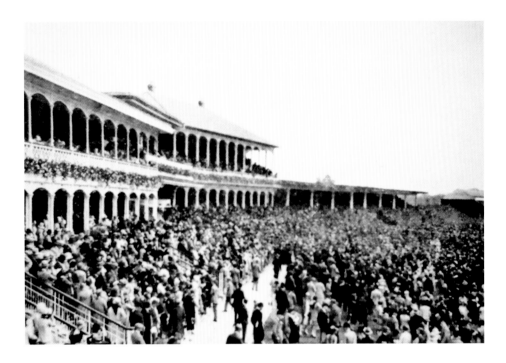

**Ebor Day 1927**
Part of the four-day Yorkshire Ebor Festival, traditionally held mid-August and also featuring Ladies' Day and Ebor, the most famous and oldest York race (it dates from the 1843), and the richest handicap in Europe. The pictures on page 31 above clearly illustrate the changing face of retail, and clothing retail in particular, between 1950 and 2011: Parliament then and Fossgate now, with the Merchant Adventurers' coat of arms reflected in the window.

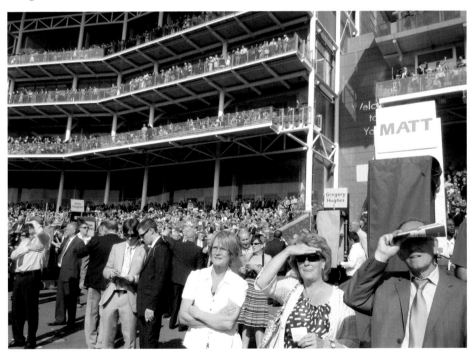

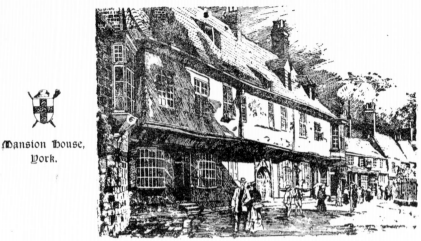

St. William's College, York.

The Lord Mayor of York and The Lady Mayoress
(Counc. Mrs. D. S. Crichton, J.P.)                    (Mrs. Harris)

on their own behalf and that of the Citizens of York, send to those Sons of the City who are on active service and to all those who carry happy memories of this City their warmest greetings and kindly remembrance this Christmas of 1941.

**Mansion House Christmas 1941**
One of the Christmas cards sent out by the Lord Mayor, Lady Mayoress and Sheriff of York in 1941, 'to those sons of the City who are on active service and to all those who carry happy memories of this City ...' and showing St William's College.

### The Unicorn

One of four York public houses to bear this name, the Unicorn in Lord Mayor's Walk is first recorded in 1852; it had four bedrooms, a taproom and a smoke room, and the family there shared their toilet facilities with the customers. It closed in 1956. The other Unicorns were in Monkgate (the 1791–1846 Malton coaching inn), Petergate (flourishing around the 1780s) and Tanner Row (from 1804–1985). The new picture is of Lord Mayor's Walk today.

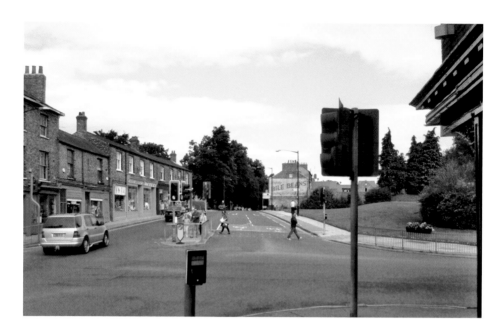

### Lord Mayor's Walk

A 1903 shot of children playing at the other end of Lord Mayor's Walk at the junction with Gillygate. The road, which follows the line of the city walls, is largely taken up with the expanding York St John University, part of an extension to which opened in 2009 and can be seen in the new picture. Around the time the older photograph was taken during the First World War, the college, then St John's College, was forced to close because the students had all gone to fight. In 1718, trees were planted down the road in an early attempt to improve the environment there.

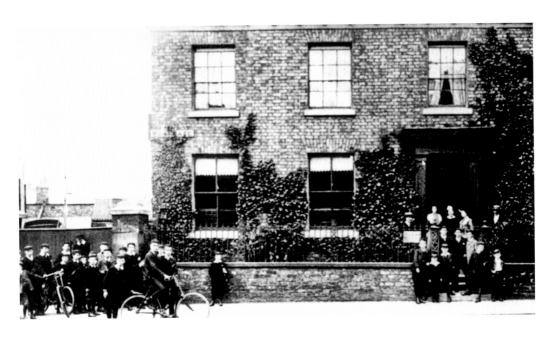

### Bridgend School and Brigadier Gerard

A private residence and the Gas Works Social Club were other uses for this school building, which in 1984 was extended and converted into the Brigadier Gerard in Monkgate. The name comes from the famous racehorse that won seventeen of its eighteen races – the one defeat was at York in 1972. The horse in turn was named after Brigadier Etienne Gerard, the hero of Arthur Conan Doyle's *Exploits of Brigadier Gerard*, a series of short stories originally published in *The Strand* magazine between 1894 and 1903.

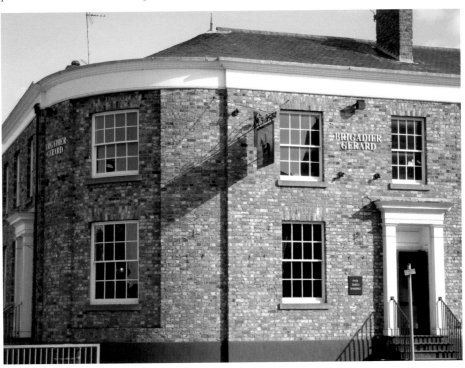

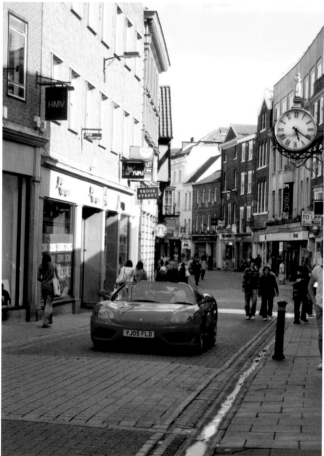

### The Bagnio

The Bagnio was down Leopard's Passage, opposite St Martin's Church in Coney Street and dates from 1691. The *London Gazette* of 19 October announces it as follows: 'Laconicum Boreale or the Northern Bagnio... where all persons who desire the same may be admitted to sweat and bath; and be cup'd (if they please) after the German fashion...paying 5s a piece'. By 1735 it had become Alexander Staples' printing office for the *York Courant*. Later, it became Ward's the Organ Builders, as here, and finally it was demolished in 1924. The new photograph shows more things Italian, with a Ferrari cruising along Coney Street in July 2011.

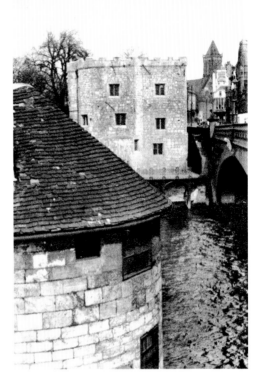

### Lendal Bridge and the Tanners

Lendal Bridge showing the North Street Postern Tower, or Barker Tower. The tower dates from the early-fourteenth century; it was given a new roof in the seventeenth century and was subject to restoration work in 1840, 1930 and 1970. The name derives from the barkers, whose job was to strip bark from oak trees to be used by tanners; hence nearby Tanner's Moat and Tanner's Row. A ferry connected Barker and Lendal Towers and a chain was slung across the Ouse here as a line of defence and to prevent merchants from entering the city without paying tolls. Uses over the years include a boom tower and a mortuary from 1879; today it is a café.

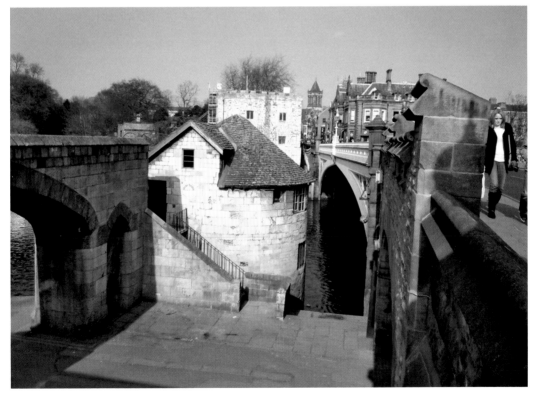

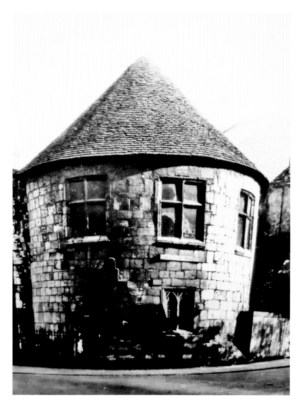

## St Mary's and the Battle of the Bowling Green

The royalist Sir Henry Slingsby has left us this record of the 1644 battle: 'Manchester, who had his Quarters about Clifton & Huworth ... makes his approaches, works his mines under St. Mary's tower without Botham barr, & rais'd a battery against ye manner Wall that led to ye orchard, he begins to play wth his Cannon & throws down peice of ye Wall. We fall to work & make it up with earth & sods; this happn'd in ye morning: at noon they spring ye mine under St. Mary's tower, & blows up one part of it, which falling outwards made ye access more easy; Then some at ye breach, some wth Ladders, getts up & enters, near 500. Sr. Philip Biron ye had ye guard at ye place ... was unfortunately kill'd as he open'd ye doors into ye bowling green whither ye enemy was gotten ...' See also page 27.

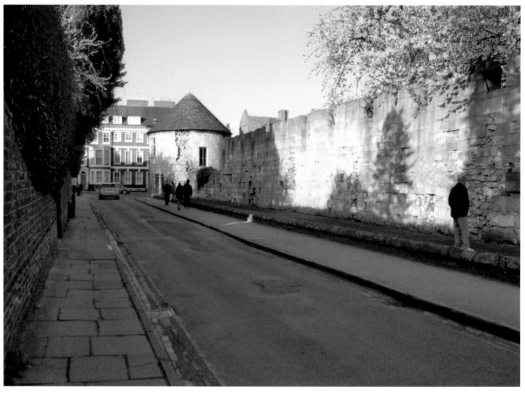

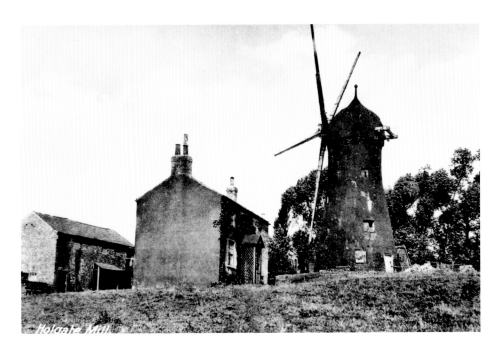

## Holgate Mill

The imposing five-sail mill is late-eighteenth century, built on the site of a fifteenth-century predecessor. At that time Holgate was a village with a population of fifty-five. The sails were damaged in a 1930 storm and taken down, after which time it was run by an electric motor. The Holgate Windmill Preservation Society looks after the mill today and organises regular tours and events.

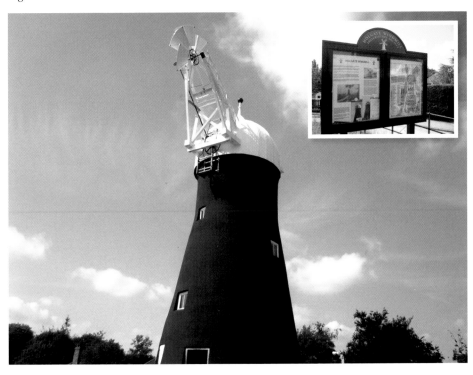

# EAST AND WEST YORKSHIRE JUNCTION RAILWAY.

## OPENING OF THE LINE BETWEEN YORK AND KNARESBOROUGH.

NOTICE IS HEREBY GIVEN, That the LINE will be OPENED for PASSENGER TRAFFIC on MONDAY, OCTOBER 30th, 1848, and the Trains will Run as follows on and after that Day :—

| Leave York. | Arrive at Knaresbro'. |
|---|---|
| 7 0 A.M. | 7 45 A.M. |
| 12 0 NOON. | 12 45 P.M. |
| 5 20 P.M. | 6 5 P.M. |
| Leave Knaresbro'. | Arrive at York. |
| 8 15 A.M. | 9 0 A.M. |
| 1 15 P.M. | 2 0 P.M. |
| 6 15 P.M. | 7 0 P.M. |

The intermediate Stations are Allerton, Cattal, Marston, and Poppleton ; and on Market Days the Trains will stop at the Flaxby, Hunwick, and Hessory Level Crossings.

OMNIBUSES will Run in Connexion with all the Trains between HARROGATE and the KNARESBOROUGH STATION.

☞ For further Particulars, see Time Bills.

York, October 19th, 1848.

**The York-Knaresborough Railway**
The 1848 opening of the York to Knaresborough line by two of the railways which became the North Eastern Railway: the Leeds Northern Railway and the East and West Yorkshire Junction Railway. The striking clock above the footbridge at York Station (with the equally striking roof in the background) was made by Gents of Leicester. The roof is 800 feet long (approximately the length of two football pitches) and 234 feet wide, 42 feet above the platforms, the longest of which are 1,500 feet long.

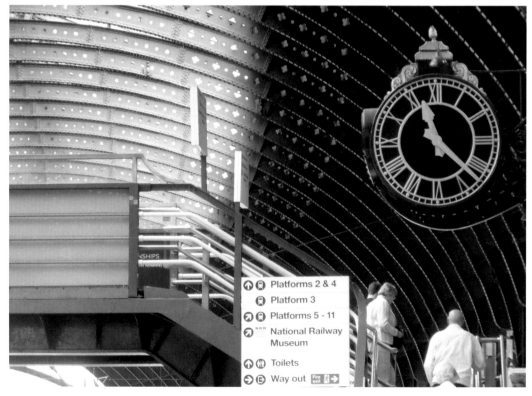

## Peter Prison and the Gurkhas

The origins of the prison and the Minster Police date from 1106 when the Liberty of St Peter and Peter Prison was formed and appointed its own constables separate from the rest of the city of York. Today there are ten Minster Police; they do not carry batons or handcuffs: their role is to look after over 380 sets of keys, to provide tourist information and to act as security for cash and fire protection. Minster security of a different kind in the new picture, with soldiers from 246 Ghurkha Signal Squadron relaxing during Remembrance Sunday 2010, weapons carefully placed on the steps.

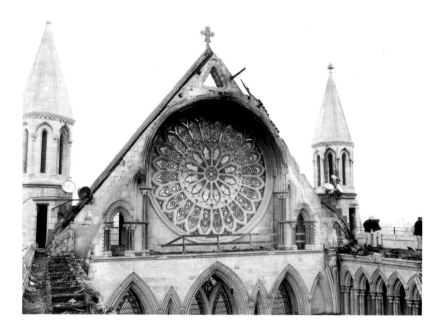

## The Rose Window

The magnificent Rose Window showing fire damage after the 9 July 1984 fire. Today, the Minster is home to one of the largest collections of stained glass in Britain; 128 windows contain two million pieces of glass. Each one is cleaned and restored every 125 years; they are each taken apart and each piece of glass is cleaned individually. The Rose Window tracery dates from about 1240 with most of the glass from about 1500; its red and white Tudor roses celebrate the end of the Wars of the Roses. The heat from the 1984 fire created about 40,000 cracks in the glass which glaziers spent two and a half years repairing and restoring to the brilliance we see today.

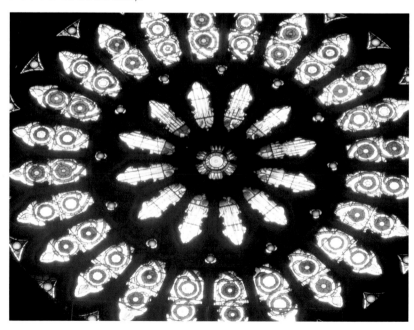

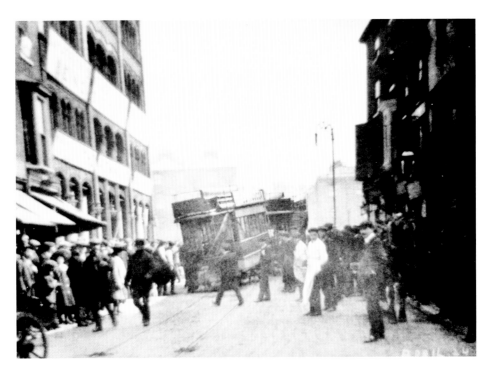

**Tram Crash**

24 April 1907 was a bad day for this tram horse and its driver when it left the rails outside Boyes in Bridge Street. The new photograph features street entertainment of a completely different, less dramatic kind, although it too attracts an audience.

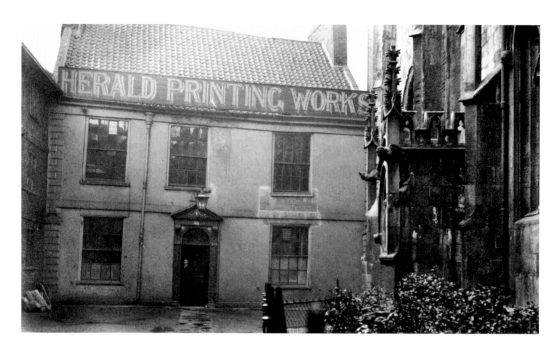

### The *Herald* in Coney Street

The four-page *York Herald and County Advertiser* was first published in 1790 in High Ousegate. It was soon making net profits of up to £1,500 and moved from weekly to daily publication in 1874, at which time it was printed in Coney Street at the former office of the *York Courant*. In 1890 it became the *Yorkshire Herald*, and eventually increased to eight pages.

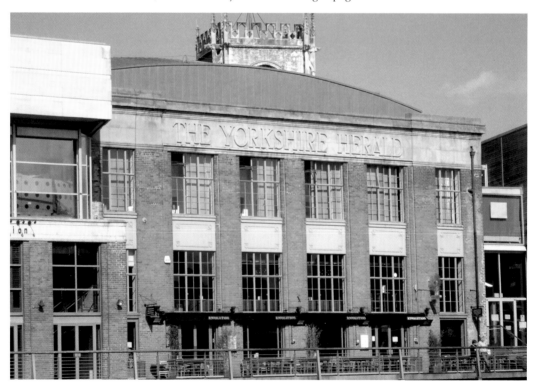

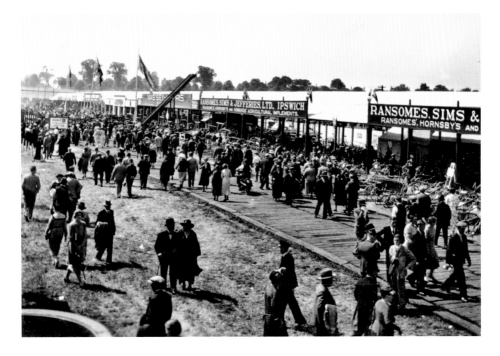

**Great Yorkshire Show 1937**

The 1937 show marked the centenary of the Yorkshire Agricultural Society and was held over fifty acres on the Knavesmire. The *Yorkshire Gazette* caught the ethos of the show when it said that it 'covered every department of rural life, and did much to provide the bridge over the gulf between the interests of town and country, which is agriculture's crying need today' – words which still ring true in 2011. The newer photograph shows scenes at the August 2011 Ebor meeting at the Knavesmire.

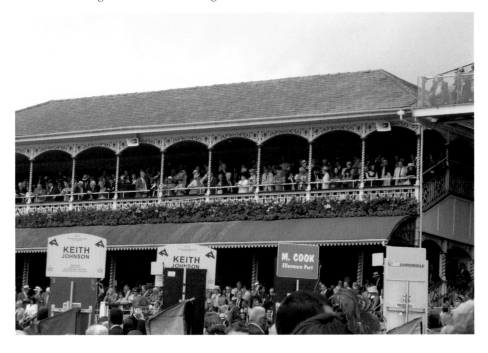

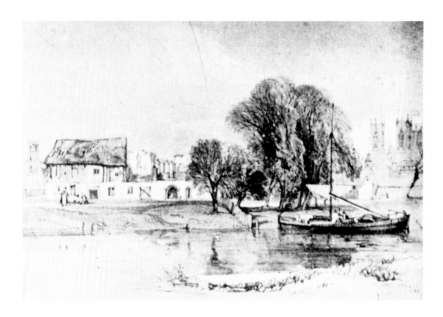

**Museum Gardens Pond**

The Yorkshire Museum was founded by the Yorkshire Philosophical Society to display their geological and archaeological collections. It was originally in Ousegate, York, until 1828 when the society received from St. Mary's Abbey ten acres of land by royal grant, in order to build a new museum. A condition of the grant was that the surrounding land should become a botanical garden. A pond was made to accommodate a large rare water lily, the *Victoria amazonica*; the older image shows it clearly with the Minster in the background. Although the pond and the conservatory are long gone, the ten-acre gardens are still a listed Botanical Garden and contain many varieties of trees, deciduous and evergreen, native and exotic.

**Winn's George Hotel on Race Day**
Rebuilt in 1614 by Thomas Kaye
with a marvellously decorated
façade, Winn's George Hotel
was one of the two Coney Street
coaching inns (the other was the
Black Swan, demolished to give
way to British Home Stores in
1955). Sadly, the railways did for
the George and it was auctioned
off in 1869 and subsequently
demolished. George Balmford dyer
and cleaner (famous for being the
first business in York to install a
telephone, linking Coney Street
with his North Street factory), Leak
& Thorpe's and Thomas Horsley,
gunsmith took its place. The colour
painting, by S. C. Maggs, shows the
George during York Races – similar
scenes of consternation can
sometimes be seen in Coney Street
today when the races are in town.

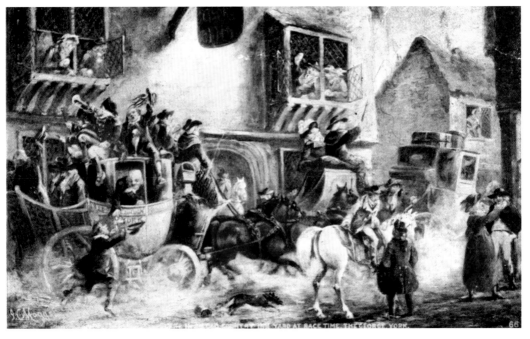

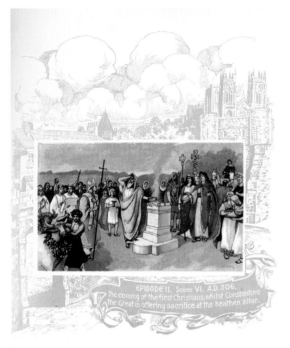

EPISODE II. Scene VI. A.D. 306.
The coming of the first Christians, whilst Constantine
the Great is offering sacrifice at the heathen altar.

Constantine and the York Pageant
The 1909 Pageant was a dramatisation
of York's history in seven episodes
from 800 BC to AD 1644. With a cast
of 2,500, the epic production involved
800 costume designs by forty different
artists and 2,000 tracings were made
and coloured; the chorus comprised 220
singers. The old image shows Episode
II Scene VI: The Coming of the first
Christians, with Constantine the Great
offering sacrifice at the heathen altar.
(Originally in *The Book of the York
Pageant*, 1909, published in a 400-copy
limited edition by Ben Johnson &
Co, Micklegate.) The modern picture
shows the powerful 1998 bronze statue
of Constantine (AD 272–337) who
converted to Christianity in 312.

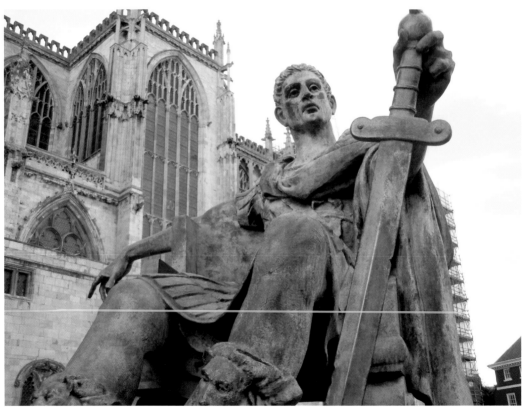

### St Crux on Pavement

An 1845 photograph of Pavement taken by William Henry Fox Talbot. The demolished buildings on the left are largely replaced by Marks & Spencer; the *York Herald* building is on the right. See pages 15 and 16 for the Parish Hall, which now houses the 1610 monument to Sir Robert and Lady Margaret Watter. In 1736, Francis Drake described the tower as 'a handsome new steeple of brick coined with stone.' although it was less admired in Victorian times.

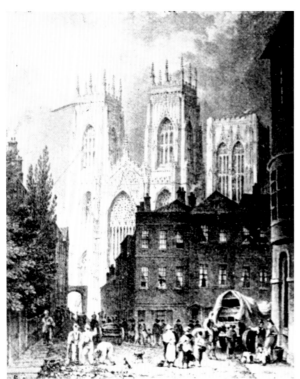

### Little Blake Street

Another 1845 Fox Talbot photograph, this time of Little Blake Street, or Lop Lane. The street was demolished in the 1850s to form Duncombe Place, but the elegant Red House to the left of the square survives. St Wilfrid's Roman Catholic church was built later, in 1864. The Red House dates from 1718 – its candle snuffer can still be seen. Dr John Burton (Tristram Shandy's Dr Slop) once lived there. It is now an antiques centre. Burton was a gynaecologist and medical author, whose books include *An Essay Towards a Complete System of Midwifery*, illustrated by no less an artist than George Stubbs. Stubbs had come to York (then, as now, a centre of excellence in medical science) to learn his anatomy. He found work teaching medical students, before taking up comparative anatomy and painting his famous horses.

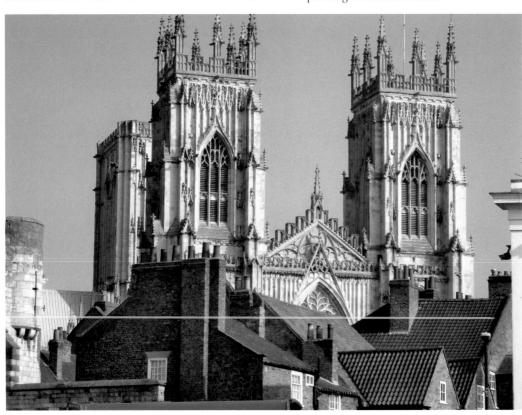

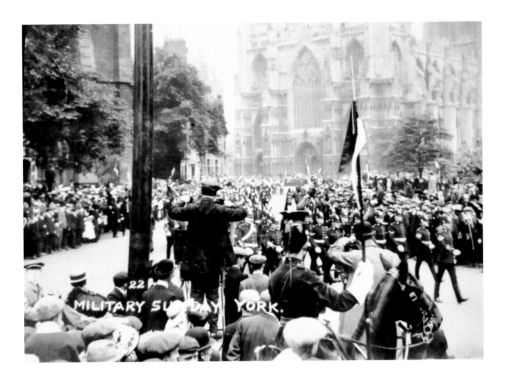

## Military Sunday Parade

An annual event in York from 1892 up until the start of World War One. This photograph shows participants and spectators in the Military Sunday Parade, in Duncombe Place. The parades were set up on the instigation of Dean Purey-Cust in tribute to General Charles George Gordon, who died defending Khartoum against Sudanese rebels in 1885. The new picture shows part of the 2011 Remembrance Sunday parade, with troops on the way to the Cenotaph.

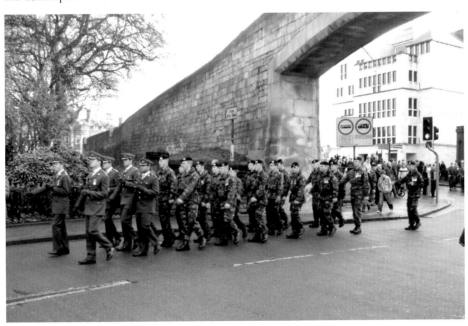

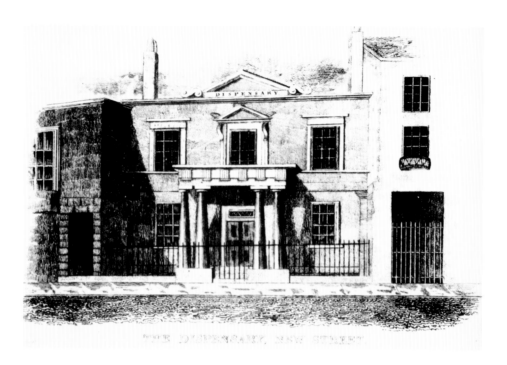

### The York Dispensary

The York Dispensary, set up to look after York's population of sick poor, was originally in the Merchant Adventurers' Hall. It moved first to St Andrewgate and then, in 1828, to New Street, as pictured here. The next move was to the majestic, often overlooked red brick building in Duncombe Place in 1851. Medicines were free of charge and children were vaccinated here. The corporation contributed £5 towards an apothecary's shop and one guinea a year for five years.

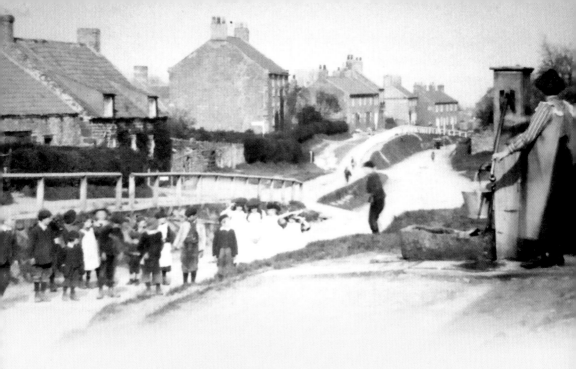

# CHAPTER 3

# North of York

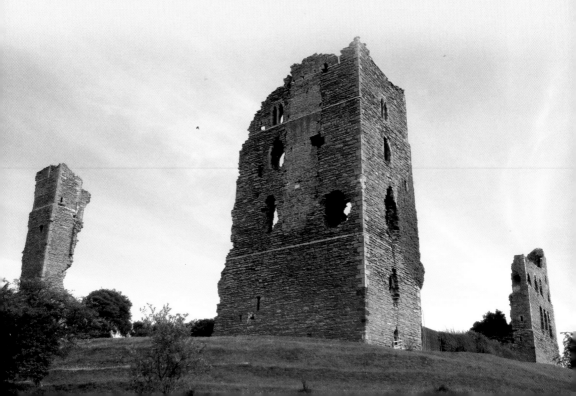

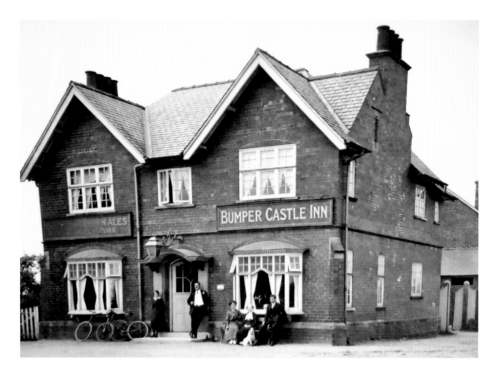

## The Bumper Castle

The Bumper Castle in Wigginton Road was built by William Johnson, landlord of the Three Cranes in York until 1846. His widow took over on his death in 1879. She was the oldest licensee in the UK when she died aged 102 in 1907. The pictures on page 57 show the water pump in Sheriff Hutton and the remains of the castle today.

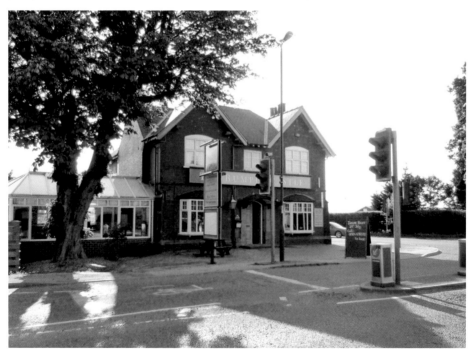

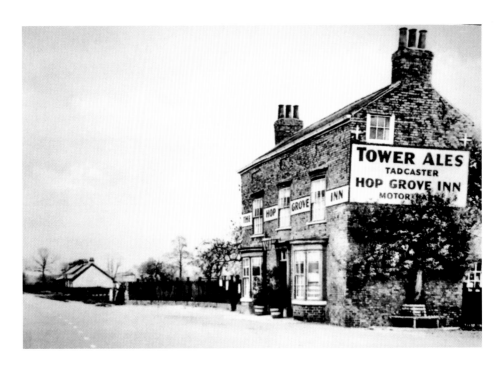

## The Hop Grove

The Hop Grove on Malton Road has been around since 1857 at least. Records refer to it under the name the Hop Pole Inn in 1889 and 1893. The old picture shows the original public house. This was replaced in the 1930s by the building in the new picture. For a short period from 1997 it was renamed the Stockton-on-the-Forest.

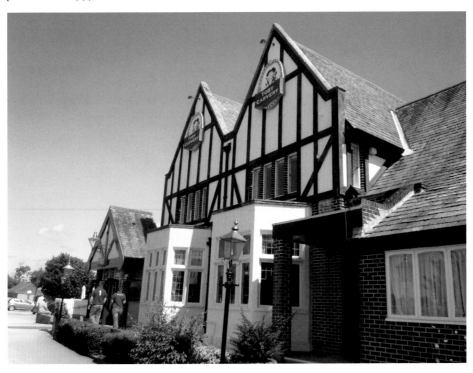

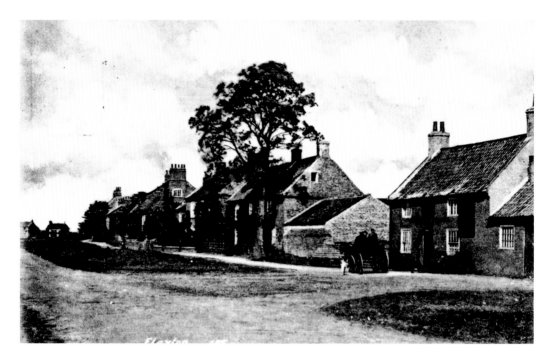

## Flaxton

The Blacksmith's Arms, on the near right in the old picture, is an eighteenth-century coaching inn; the corresponding new photograph shows how little has changed over the years. Another local concern maintaining the village's rural heritage is Flaxton Forge, Artist Blacksmiths and Fabricators. Flaxton railway station on the York to Scarborough line opened in 1845 and closed in 1930.

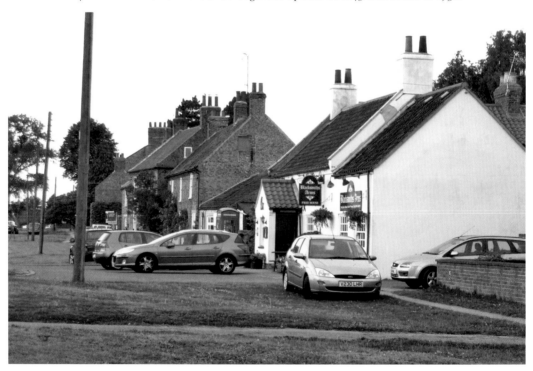

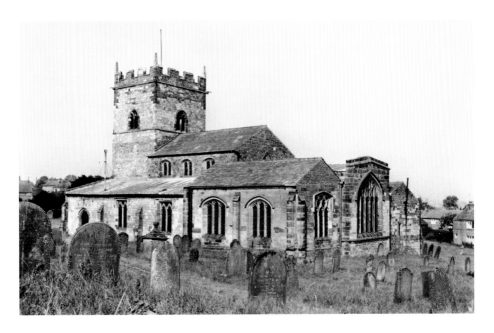

### St Helen and the Holy Cross, Sheriff Hutton

The earliest reference to the church of St Helen and the Holy Cross is as a gift to St Mary's Abbey York by Sir Nigel Fossard, in around 1120. The church houses an alabaster tomb, allegedly containing the remains of Edward, Prince of Wales, son of Richard III and Anne Neville. Richard III probably visited Sheriff Hutton several times in around 1485 when he created The Council of the North, which met in either York or Sheriff Hutton. The motto on the coat of arms in the church translates as 'I wish for fair play'.

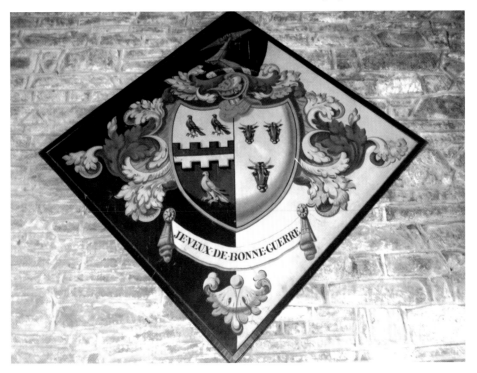

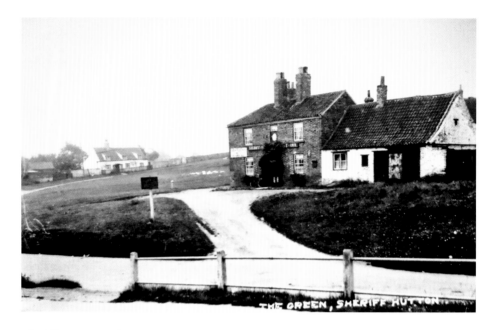

## Sheriff Hutton and Its Two Castles

Everyone knows that Sheriff Hutton has a castle – what is less well known is that it has in fact had two castles. The earlier castle was a Norman motte-and-bailey structure from 1140, of which only the mounds survive. It was built by Ansketil de Bulmer on land given to him by William the Conqueror for his support in the conquest. The Sheriff part of the village's name derives from its connections with the Bulmer family. Ansketil and Bertram de Bulmer were High Sheriffs of Yorkshire in the periods 1115–1128 and 1128–1130 respectively. The pictures show the little-changed Castle Inn on the village green.

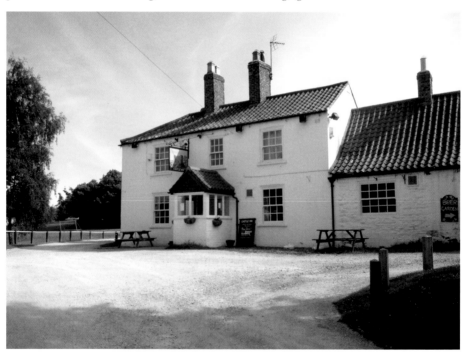

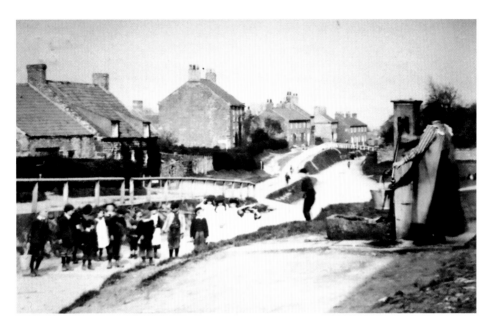

### 'Few Villages Touch National History so Closely as Sheriff Hutton'

So said John Rushton in his *The Ryedale Story*. The village passed into the hands of the Neville family in 1115 and in 1382 John Neville began construction of the second castle which was completed in 1398. In 1484, Richard, Duke of Gloucester, set up the Council of the North, with its headquarters at Sheriff Hutton castle. After about 150 years, the Council relocated to York and so began the castle's gradual decline into the dramatic and imposing ruin we see today.

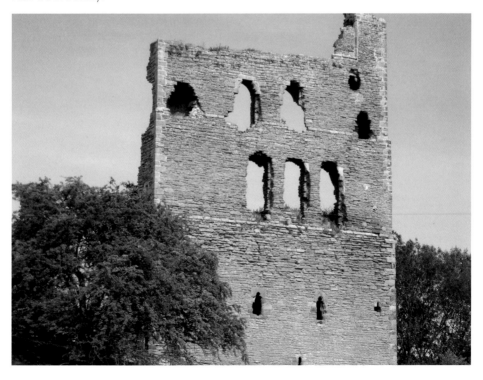

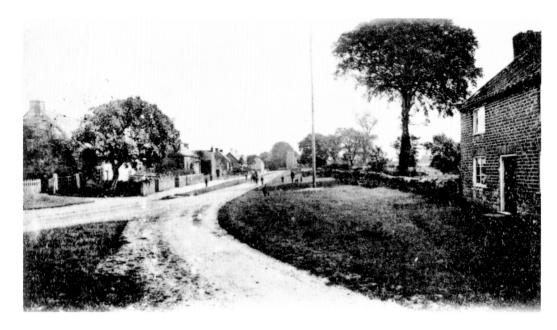

## The Wapentake of Bulmer

The seat of the ancient wapentake of Bulmer, the name of this delightful village means 'the lake of the bull'. The Bulmer family who lived around here in the twelfth century are named after the village. Ansketil de Bulmer, High Sheriff of Yorkshire, has the earliest records. The village school is now the village hall, and the pub, blacksmith, shop and agricultural workshop are all closed. St Martin's is the village church, just visible in the older picture; Domesday tells us that a church and a priest existed at Bolemere.

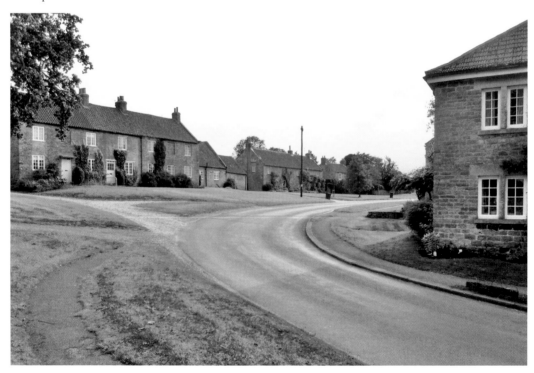

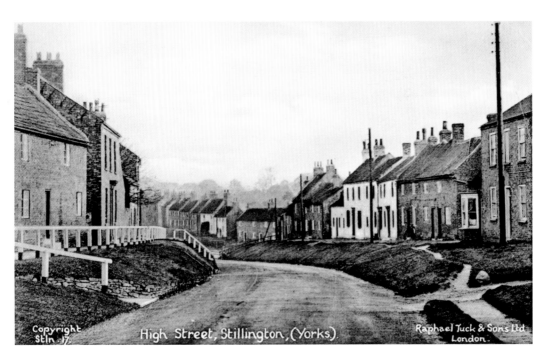

High Street, Stillington, (Yorks).

## Stealing Town

Thomas Gill would have us believe, in his 1853 history *Vallis Eboracensis*, that the name Stillington derives from Stealing Town – a reputation won by the locals' habit of 'robbing the king's forest of its deer, and the packmen of their merchandise'. Be that as it may, the true derivation of the name is pre-Conquest: Domesday has it as 'Stivelincton', held by the Archbishop of York and worth ten shillings a year. Stivel is a Saxon personal name.

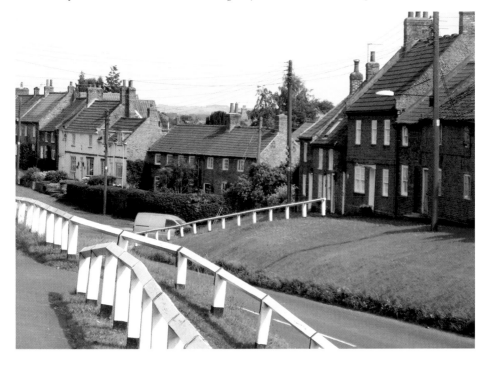

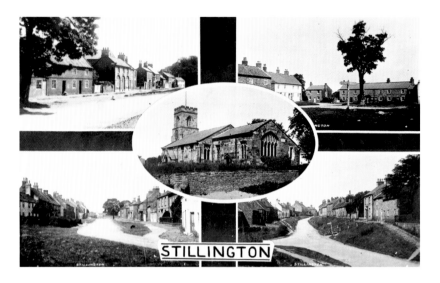

### Stillington and *Tristram Shandy*

Laurence Sterne (1713–1768) was vicar here from 1743. He is reputed to have flung the manuscript of his *The Life and Opinions of Tristram Shandy, Gentleman* onto the fire, when he detected a notable lack of interest amongst his audience at an early reading. It was salvaged and went on to be regarded as one of the greatest comic novels in English. The inset shows a 1930s LNER poster by Austin Cooper. It depicts a scene from the novel outside Shandy Hall in Coxwold, where Sterne is now buried. The first attempt at interment was unsuccessful. His body was exhumed from its Hanover Square grave by 'resurrection men' and sold to the Department of Anatomy at Cambridge University. Unfortunately – or fortunately – the Professor of Anatomy recognised the cadaver. Sterne's remains were finally transferred to Coxwold by the Laurence Sterne Trust in 1969. The church in the new photograph is St Nicholas' which dates from the twelfth and fifteenth centuries, and was restored in 1840.

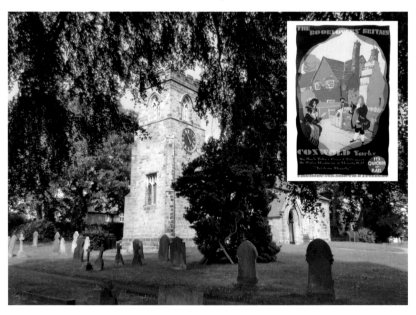

## Sutton-on-the-Forest: The Blackwell Ox

The Blackwell Ox was originally a private residence built around 1823 for a Mary Shepherd. The name derives from a shorthorn Teeswater ox registered under the name of The Blackwell Ox, which was bred and raised by Christopher Hill. The ox was six feet tall and weighed 2278 lbs; when it was slaughtered and butchered in 1779 the meat fetched £109 11s 6d.

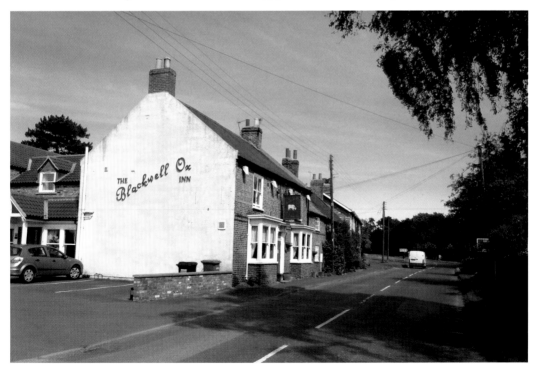

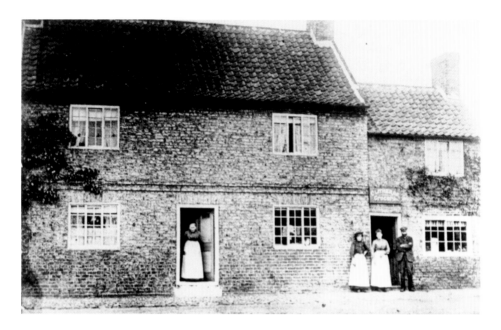

### Sutton and Sterne

Laurence Sterne was vicar here too (1713–68) but moved on to Coxwold when his parsonage burnt down. During his stay he published the first two books of *The Life and Opinions of Tristram Shandy, Gentleman,* possibly basing it on the village and its characters. The novel was published over ten years from 1759–1769. The cottage here is Willowmead, known previously as Wight Cottage and Rose Cottage. The school entrance is next to Clitheroe's the grocer, on the right. The new photographs here and on page 69 show the fine cottages for which Sutton is well known.

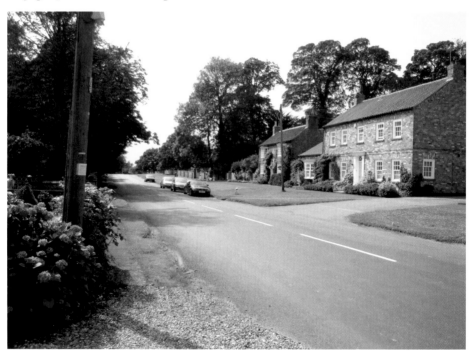

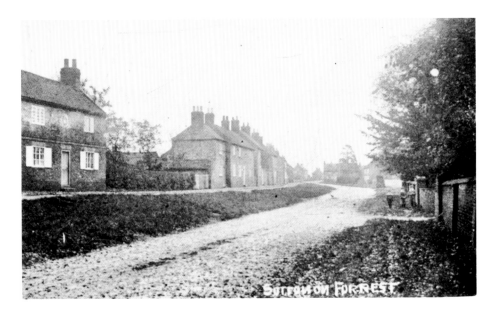

## Rococo Plasterwork by Cortese

Green Bank is the house on the left of the older photograph, with the wall of Sutton Park on the right. A fine example of early Georgian architecture, Sutton Park was built by Thomas Atkinson. Apart from his own impressive house at 20 St Saviourgate, York, Atkinson was responsible for remodelling the façade and gatehouse of Bishopthorpe Palace in the 1760s and for the chapel and façade of the Bar Convent in York. Sutton Park is noted for its Rococo plasterwork by Cortese, its collection of eighteenth-century furniture and its paintings, many of which came from Buckingham Palace.

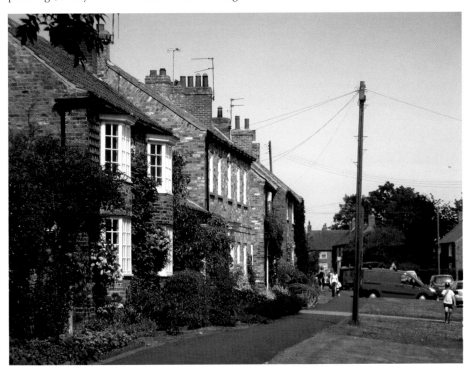

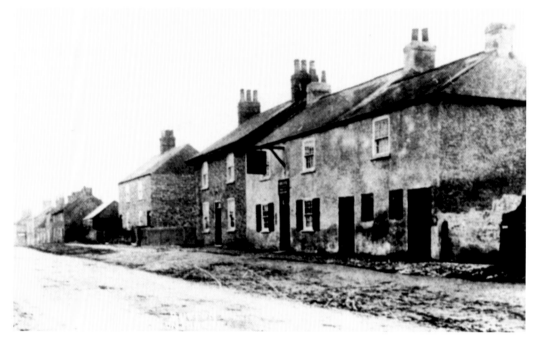

### The Rose & Crown

Sutton appears in Domesday with the following credentials: value to Lord Morcar in 1066 £32; value to lord (King William) in 1086 £1. 12 villagers, 4 smallholders and 1 priest; 27 plough hands, 5½ men's plough teams; pasture 1½ leagues; woodland 1 league; 1 mill, value 1.0; 1 church. The building to the left of the Rose & Crown was the village shop for a time, before being converted back to a private residence. Before it was a pub the Rose & Crown was a house and a stable.

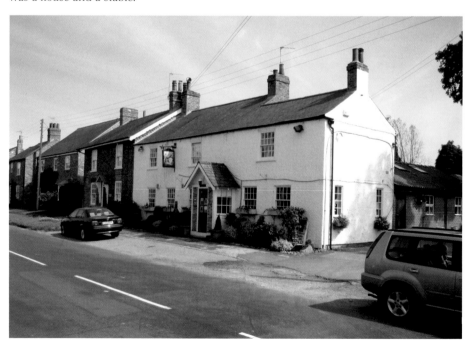

### Shipton-not-so-by-Beningborough

Shipton is not really 'by' Beningborough at all – the villages are nearly two miles apart. The connection exists because Shipton formed part of the Beningbrough Estate, which was owned first by the Bourdner and then the Dawnay families. Independence came in 1917 when the estate was dissolved. In 1655, Ann Middleton bequeathed £1,000 to for a grammar school in the village and twenty shillings a year to feed the local poor. The school was demolished in 1850 when Payan Dawnay built a new one. The public house named after the family was originally The Bay Horse, built in 1730. The A19 dissects the village and the main line from London to Edinburgh passes close by. The church is the Holy Evangelist, built in 1849.

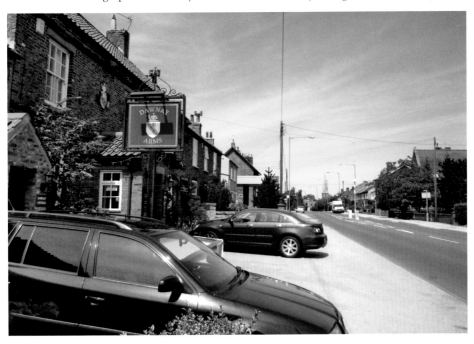

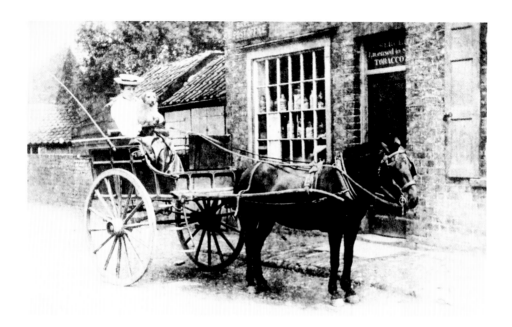

## Skelton and Moorlands

Skelton's Anglo-Saxon name in the eighth century was Shelfton or Scelfton, which means a settlement on a shelf of land. The Domesday entry is: 'a manor with a hall in Skeltun, owned by St Peter's or York Minster and Earl Alan, a supporter of William I'. The Georgian manor house, Fairfield Manor, on the road into York, was built in 1815. It was owned by a family of racehorse breeders, subsequently became a hospital and is now a hotel. Moorlands House, between Skelton and Wigginton, was built in 1864 for the Tew family and was later used as a hospital. The neighbouring wood with its stunning rhododendrons is owned by the Yorkshire Wildlife Trust. The new picture shows Skelton's green today.

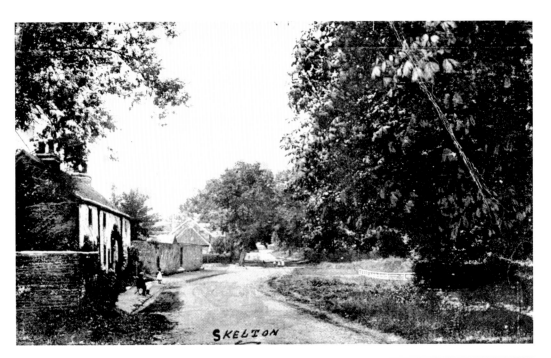

SKELTON

### The Bridge of Boats

During the Civil War, in 1644, a tax of £126 plus a wagon and horses, was levied on the village by the Royalists. Their troops camped nearby the night preceding the Battle of Marston Moor, crossing the Ouse the next morning by a "bridge of boats" at Poppleton. Just over a century later, in 1745, Skelton reacted to the threat of attack by the army of Bonnie Prince Charlie by planning an evacuation by boat and preparations were made for the boarding up of the church.

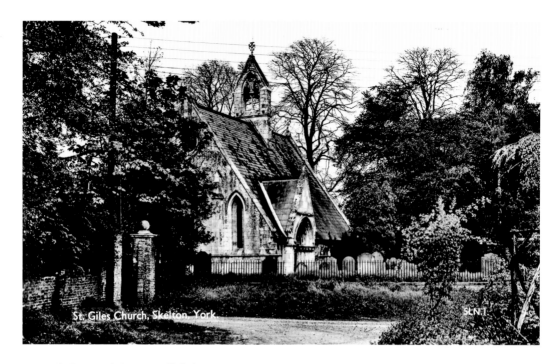

St. Giles Church, Skelton, York.

### Skelton and the Moonlighting Masons

St Giles' Church was built in the Early English style in around 1247; it is one of the most complete examples of a thirteenth-century English parish church still in existence. Masons working on the North Transept of York Minster built St Giles' with narrow lancet windows, dogstooth moulding and Gothic detailing common to both buildings.

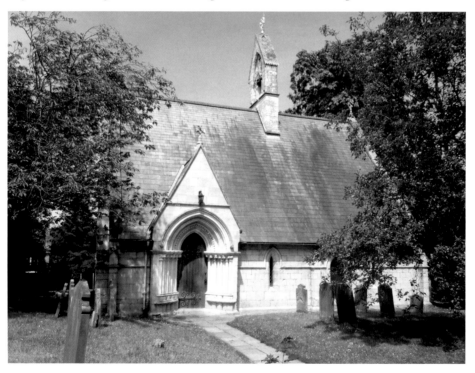

# CHAPTER 4

# East of York

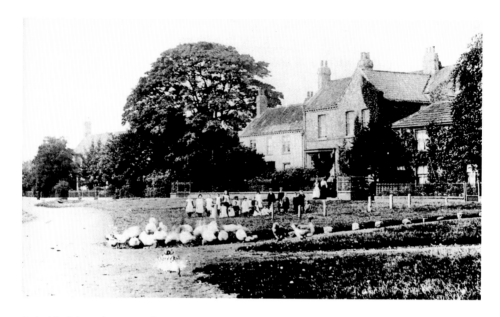

## Osbaldwick and Its Erratics

A shot from around 1900 showing geese on the green being watched by children being watched in turn, presumably, by their teachers. Osbaldwick is Osbaldeuuic in Domesday; the name derives from Osbald, a Northumbrian earl who ruled here in the eighth century. Osbaldwick borders the Roman road from York (Eboracum) to Brough (Petuaria). A number of erratics (huge glacial deposit boulders of Shap granite) used to lie on the village green. They are now in the Yorkshire Museum Gardens. The new picture and that on page 75 show one of the beautiful gardens in the village in the summer of 2011.

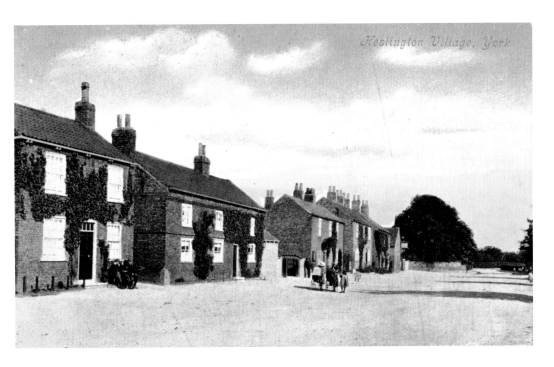

## Heslington and Bomber Command
Lord Deramore was the Lord of the Manor during the 1930s and the owner of Heslington Hall, later to become part of the University of York in the 1960s. Heslington Hall was built in 1568 for Sir Thomas Eynns, who was secretary to the Council of the North from 1550–78. During the Second World War it was requisitioned as Headquarters of 64 Group, Bomber Command.

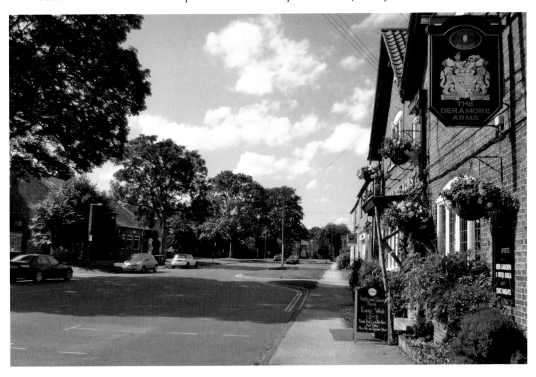

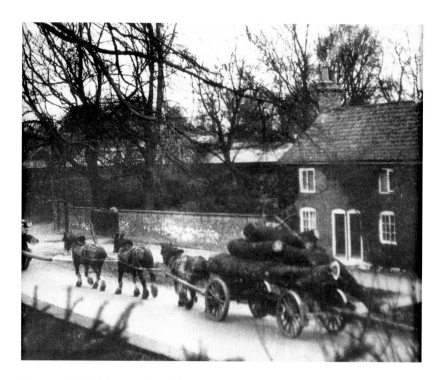

**Charles XII, Robin Hood and the Fox**

Heslington in the 1930s, with timber after a spot of tree-felling. There were three alehouses here in the eighteenth century: in 1823 there were the Robin Hood and the Ship, by 1840 renamed the Bay Horse and the Fox respectively. The Bay Horse was then rebadged the Charles XII after the winner of the 1839 St Leger flat race. In 1872 the Fox was later called the Yarburgh Arms and renamed again in 1967 as the Deramore Arms.

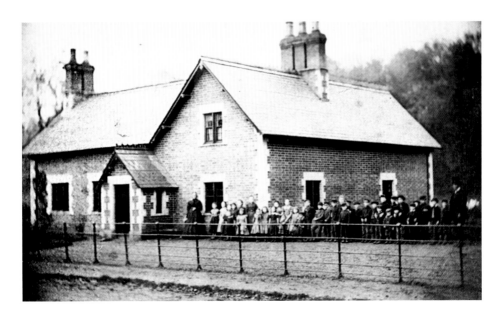

### The Sand Hutton Fire Brigade

Sand Hutton was owned by the eccentric Sir Robert James Milo Walker, Bt. (born 1899). Walker constructed his personal narrow-gauge steam railway to convey himself around his extensive estate; he also had his own fire brigade. G. J. M. Fitzjohn, in his series of articles, entitled 'Historic Houses of Yorkshire & Lincolnshire' published in the *Hull Mail* in 1928 tells us that 'All the firemen are directly employed by Sir Robert Walker on his estate and to use his own words "If I was to blow my whistle, before you could say a word, they would be round here like bluebottles" ... men are always working in the garage so that in a fraction of a second the prepared fuel is ready for ignition.' The old photograph shows the school in 1890.

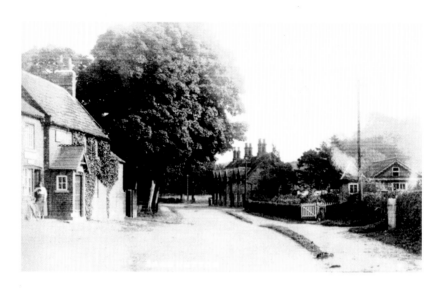

### The Sand Hutton Light Railway

Eight miles of 18-inch-gauge railway made up the SHLR running all over Walker's estate with termini at Sand Hutton and at Warthill, where it joined the LNER with branches to Claxton, Barnby Farm, and Sand Hutton Hall. It employed four locomotives and seventy-five two-ton wagons plus a brake van. A special feature was the passenger coach which seated thirty-six passengers. The main function was to carry market produce from the estate and bricks from the brickyard to Warthill or Claxton (see page 75, bottom right). The old 1920s picture has the forge and post office on the left. The new photograph shows part of DEFRA's Central Science Laboratory, responsible for our agriculture, sustainable crop production, environmental management and conservation, and food safety and quality. The National Collection of Plant Pathogenic Bacteria is also here.

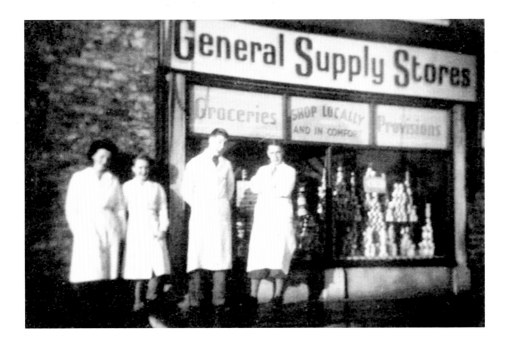

## Claxton and Gordon Gordon's Shop

The General Supply Stores was next to the 1850 Primitive Methodist chapel and was the last of a long line of shops here dating back to the 1830s. R. Newbold sold the shop to a Thomas Wilson in 1843; Arthur Turner, pictured here on the right, bought it in 1946. In 1994 it was sold again by Gordon Gordon and eventually became a private residence. The inset shows a 1920s advertisement for the shop.

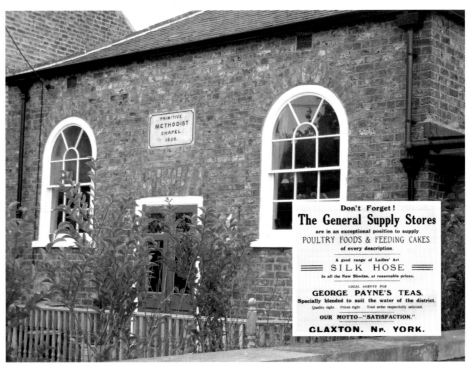

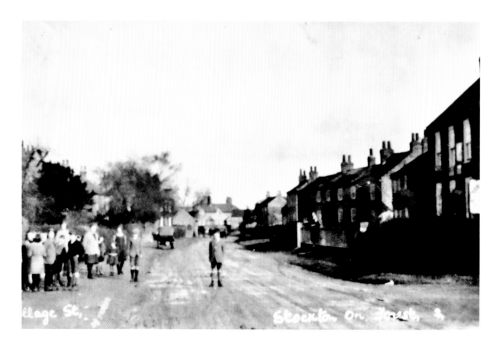

### Stockton-on-the-Forest

Stockton-on-the-Forest is a good example of a linear village. It is built almost entirely along one main road for 1½ miles. It is also remarkable in that the houses along this main road are not blessed with house numbers but instead have random, individual names, many of which have agricultural or mystical associations. The photographs show a busy village and the grounds of the Stockton Hall Hospital.

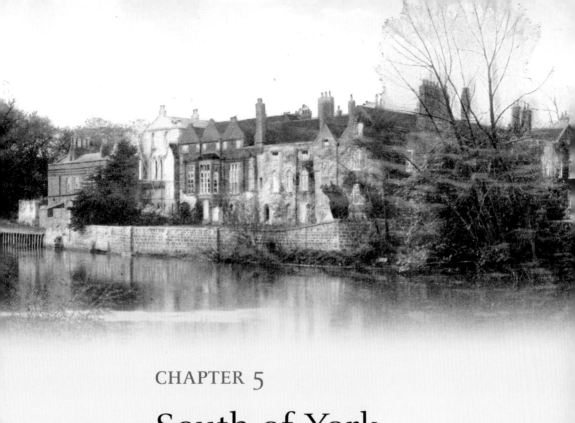

# CHAPTER 5

# South of York

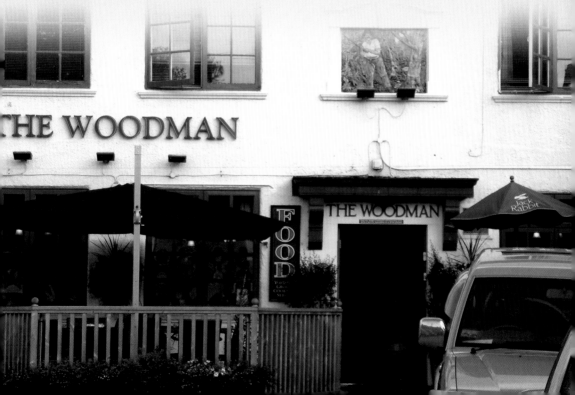

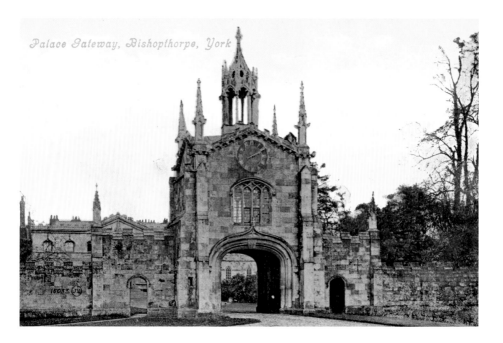

Palace Gateway, Bishopthorpe, York

## Bishopthorpe

The original name was Thorpe, as given in Domesday, then Thorpe-on-Ouse in 119. In 1202 the monks of St Andrew's at Fishergate built the first church here and the name became Andrewthorpe, Thorpe St Andrew or St Andrewthorpe. the change to Bishopthorpe came about in the thirteenth century, when Archbishop Walter de Grey bought the manor house and presented it to the Dean and Chapter of York Minster. Bishopthorpe Palace was thus born; it has been the residence of the Archbishop of York ever since and is currently the home of Dr John Sentamu.

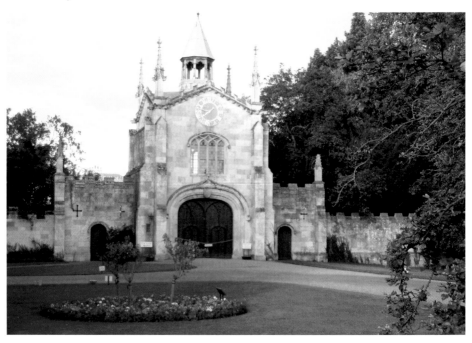

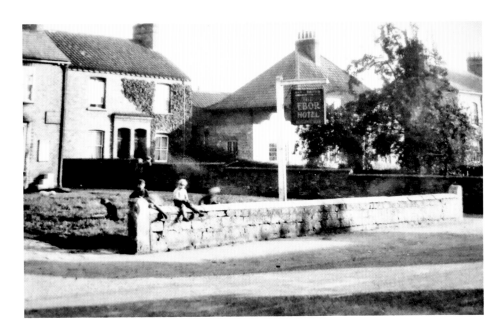

### The Riot of Bishopthorpe

In 1323 a truce was signed here between Edward II and Robert the Bruce after the Battle of Bannockburn. Archbishop Drummond's renovation of the Palace in 1763 produced the Strawberry Gothick west front and gatehouse. In 1832, the Reform Bill saw rioters trying to overrun the Palace, incensed by Archbishop Harcourt's lack of support. Bishopthorpe is the setting for *The Lost Luggage Porter* by Andrew Martin, an Edwardian crime novel which uses the old name of Thorpe-on-Ouse. The protagonist, railway detective Jim Stringer, lives on Main Street, Bishopthorpe, and is a staunch patron of the local hostelries, not least the Woodman with its colourful sign and the Ebor, formerly the Brown Cow.

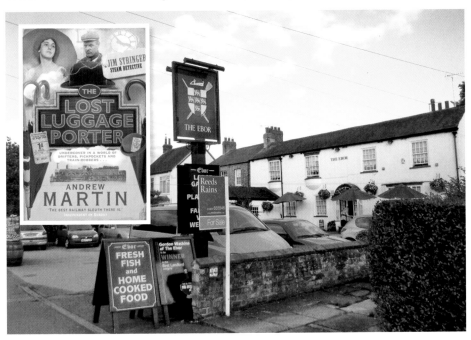

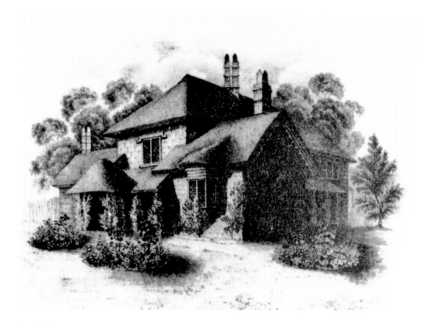

## Escrick

The village was originally known as Ascri, meaning ash ridge, but by 1600 it was being called Escrick. It was designed as an estate village by Sir Henry Thompson, who had bought the village and the Hall in 1668. In 1783, a new St Helen's Church was built on the York Road to replace the original thirteenth-century one at the Hall. The old image is of one of the four surviving nineteenth-century cottages in the Pleasure Grounds of Escrick Park, today the house of the head of Queen Margaret's School. The new photograph shows the tower of St Helen's Church with gargoyle and flag.

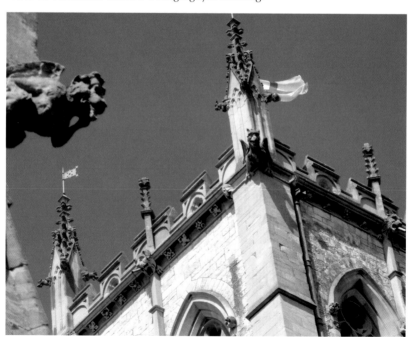

## Mr Etches and Mr Duckles

Queen Margaret's School now occupies Escrick Hall, as seen in the old image from 1931, but educational provision here goes back as far as 1586; a school for ten pupils existed in 1743, with pupil numbers rising to 142 by 1844. Teachers around this time included Mr Etches (art?), Mr Hullah and Mr Duckles. The 1783 church was replaced in 1857 by the current Gothic church which, designed by Francis Cranmer Penrose, architect and surveyor at St Paul's Cathedral, cost £26,000. The new photograph is of the Parsonage Hotel, once the Rectory.

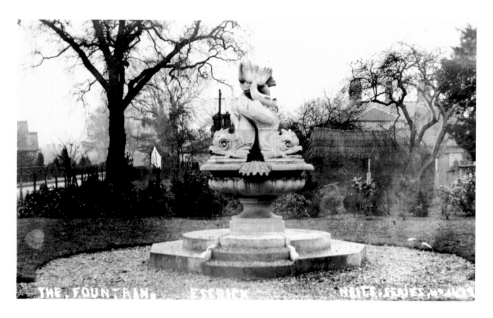

THE FOUNTAIN. ESCRICK

## Escrick in the Second World War

Escrick and the surrounding area had an eventful Second World War, situated as it was close to RAF bases at Acaster Malbis and Riccall. Riccall was home to a Heavy Conversion Unit retraining aircrew to fly Halifaxes. Two crashed near Escrick in 1943, killing fifteen crew members in total. Nearby Elvington was the base for Britain's only two Free French bomber squadrons (346 and 347): in 1945 a Halifax taking French aircrew home after the war crashed at Sheepwalk Farm, killing three Frenchmen. The last German plane to be shot down over Britain, a Junkers 88, crashed into a farm at Elvington in March 1945, killing two of the occupants. The dolphin fountain was erected in 1897 to mark Victoria's diamond jubilee.

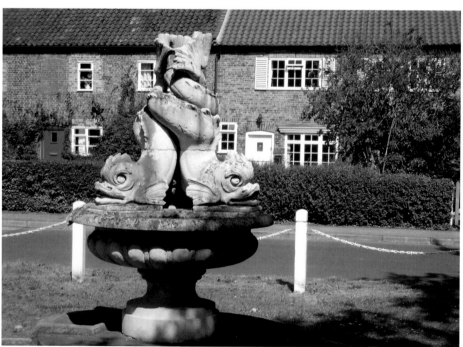

CHAPTER 6

# West of York

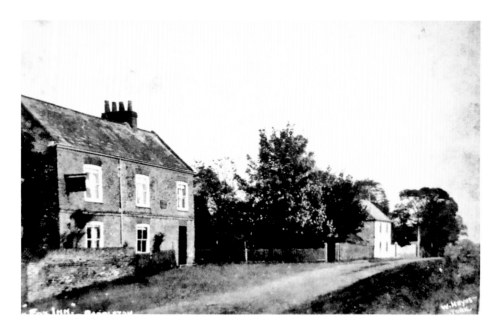

Nether Poppleton

The Fox Inn in Church Lane started life on the other side of Church Lane, or Town Street, in around 1822; In 1898 the licence was transferred to premises extending down to the River Ouse. The new building was demolished in 1965 and rebuilt, only to close in 1997. The pictures on page 89 are of St John the Baptist at Kirk Hammerton and the green at Upper Poppleton today, with maypole. The church was originally, and uniquely within Britain, dedicated to St Quentin and still retains many Saxon features.

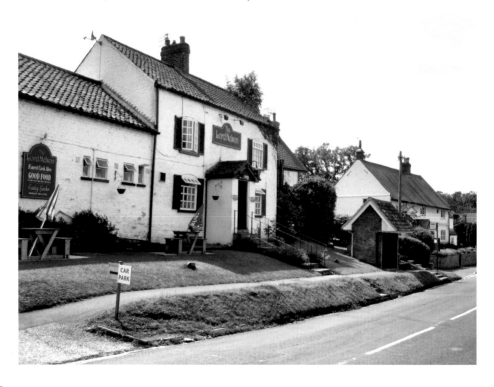

## Popeltune

The village features in the 972 *Anglo-Saxon Chronicles* as Popeltun and in Domesday as Popeltune. A mayor of York was murdered here during the reign of Richard II. In 1644 the Earl of Manchester's 25,000-strong Parliamentary army built a bridge of boats at Poppleton, later taken by Prince Rupert and his Royalist Forces. The older photograph is a 1920s street scene in Nether Poppleton; the new one is of the cenotaph and Methodist church opposite the green in Upper Poppleton.

## Isolde del Shippe

There was probably a ferry here from 1089 when monks from St Mary's Abbey in York would have used it to visit their properties here and in Overton. The aptly named Isolde del Shippe is the first known ferrywoman, in 1379. Records from Trinity House in 1698 mention a ferry at Poppleton, a popular service which lasted until the 1960s, albeit in a different location, behind what is now Ferry Cottage on Main Street. The café boat was very popular; tea could also be had in the riverbank gardens of Priory House.

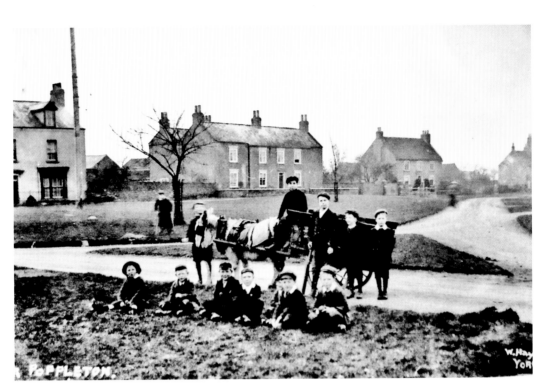

### Land Poppleton and Water Poppleton

The name comes from popel – pebble, and tun – farm or hamlet and describes the gravel bed on which the village is built. Upper Poppleton is sometimes referred to as Land Poppleton while Nether Poppleton is Water Poppleton, denoting their locations in relation to the river Ouse. How play used to be is shown in the splendid postcard of the green. The new photograph shows the tower of the 1890 All Saints' church which replaced the Norman Chapel of All Hallows.

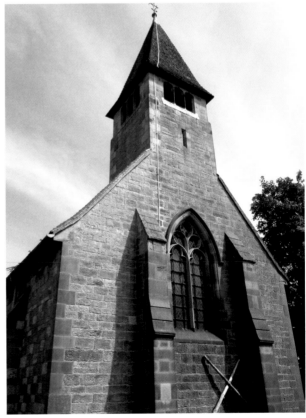

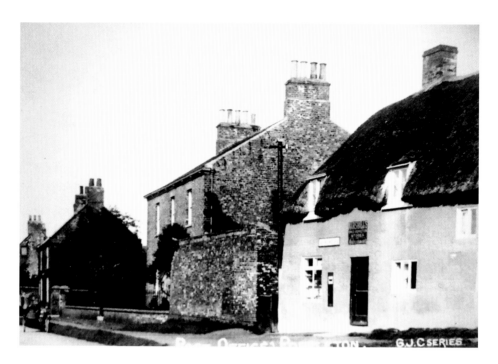

## Upper Poppleton

The first recorded school in Upper Poppleton appears in 1797, when John Dodsworth paid for a school to be built on the corner of Church Street and Main Street. It taught an equal number of pupils from both Poppletons. The local parish church was in York – St Mary Bishophill Junior – although locally All Hallows was allowed as a Chapel of Ease.

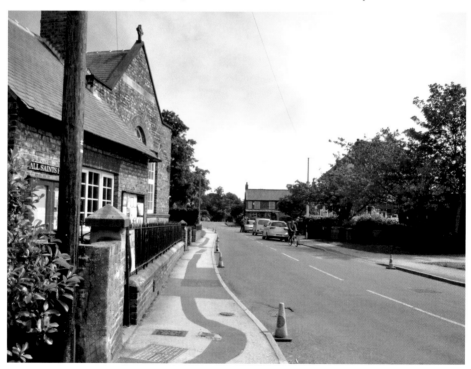

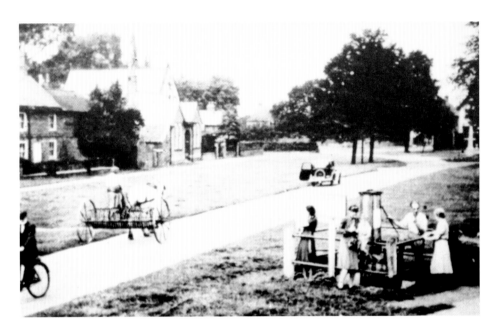

## Upper Poppleton and John Wesley

The water pump still can be seen today on the green, close to the maypole. This old picture shows how busy it could get. It was probably Poppleton's Red Lion that John Wesley visited in 1743. At this time the landlord was a Charles Hodgson, hence Hodgson Lane. Wesley's diary entry for 18 February that year reads: 'We enquired at Poppleton, a little town three miles beyond York, and hearing there was no other town near, thought it best to call there.' The inn was also called the Four Mile Post and Poppleton House at various times.

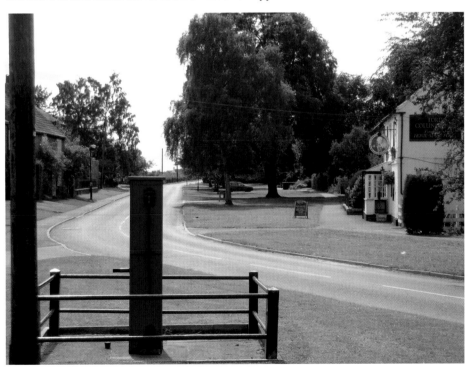

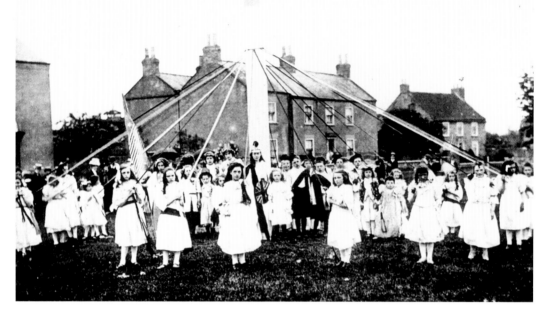

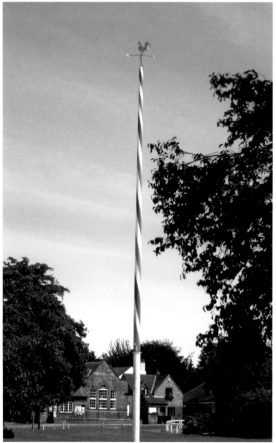

### John Wesley Pelted with Eggs and Mud

Wesley returned in 1757 and he preached on the green, on a day that was 'violently hot'. The next day, in York, he was pelted with soil and eggs. The Lord Collingwood, opposite the green, dates from 1823. It is named after Vice Admiral Cuthbert Collingwood, Nelson's second-in-command at Trafalgar, who assumed control of the fleet after Nelson was killed. Collingwood himself was killed at Toulon in 1810 and is buried in St Paul's Cathedral.